DRAWING THE HILLY FIELDS OF NORTHUMBERLAND

Pastel Drawings

By

GARY WALTERS

COPYRIGHT

GARY WALTERS

HASTINGS, ONTARIO

2013

ISBN 978-1491280126

PRODUCED BY VECTOR PRINT AND PUBLISHING

vectorpandp@gmail.com

Dedicated to my parents

ELEANOR GRACE WALTERS

RICHARD ARTHUR WALTERS

And my grandmother

LAURA BILTON ROBERTS

The gleam of love in their eyes never fades in mine.

INTRODUCTION

These drawings were made between the spring of 2011 and the fall of 2012 in the Northumberland Hills of South Central Ontario. The glaciers of the last ice age left here a particular combination of small hills called drumlins with wetlands and little lakes between them. The native peoples used the interconnected streams and wetlands for transportation and generously showed these routes to the earliest European explorers. In fact Samuel De Champlain used the portage going through our land. It has always been called the Percy Portage and retracing its path was done in the 1980's by Trent University one of whose orange markers is still at the bottom of our property.

Farming here required the removal of thousands of rocks for each field cleared. The fields climb up and down the slopes, are bordered by the heaped up stones, trees and hedges, scraggy fences, and altogether the resulting landscape resembles a quilt. Over it all is a large infinitely changing sky providing the drama of light and shade, color, rhythm, tempo, proportion, and space. In this landscape we feel we can be very near or very far but never lost.

During a drive one day I realized that I had gathered many impressions of this landscape over the decade we have been living here. So I began to put down the impressions, not on the spot, but just as soon as I could after getting home. I set up a spot in the kitchen for the notebooks and pastels on an old jam cupboard.

For a year and a half or more the accumulating drawings would be right there as we went in and out the front door. In that time I think I made over a hundred drawings. As the seasons and weather changed, as the fields were tilled or lay fallow, as the crops were planted and matured, the drawings followed these changes. They are memories of an impression that struck me on any given day. There is therefore no attempt at a precise rendering, but rather the quick recording of an imprint made on my mind as I looked at the passing scenery. It is a landscape I have come to love and value, intricate yet humble, subtle and yet clear, homage to a rural harmony between nature and farming. Although never intended as such the resulting cooperation has a unique character which I hope I have captured in my drawings.

Painting in the open air, "plein-air" painting associated with the Impressionist movement actually has a long history. In practice, however, the sketch or painting done outside is usually finished inside or forms the basis for a larger formal painting. The ideal of "Nature" as a good in itself, the contemplation of nature and natural beauty as a corrective to the ills of social life and industrialization is the result of the Romantic movement in Western intellectual history and taste. That is to say, since about 1750 and the writings of Jean Jacques Rousseau and others.

Pastels are made from the same pigments found in oil and other paints. The pigments are bound most often in gum arabic or gum tragacanth. The addition of chalk to this mixture will change both the intensity of the color and the hardness

of the eventual product. The best pastels have traditionally been made in France. Today there are many grades and an extraordinary range of colors. The word pastel derives from the Latin for paste, "pastellum", since this is what the mixing of the above ingredients first produces until it dries. Round or rectangular lengths are made from this material and so we have a medium that is suitable both for drawing and for blending colors. This fusion of drawing and pure color solves one of the great problems of two dimensional art for an emphasis on one is almost always to the detriment of the other.

I always work quickly so the pastel medium is perfect for capturing an idea and then elaborating aspects of that idea. The medium as such suggests change, the insubstantial; at once a view and a sense of the passing of that view.

Landscape painting has only recently become a subject in itself. It was used only for decoration or to suggest an appropriate setting or for the pleasure and interest of an artist or an amateur. But since 1750 it has become the most popular of all subjects in high art in Western painting. And this is at a time when "nature" is threatened as never before and we are not quite sure whose "nature" is whose or, more troubling, where it is or what it is. These remarks help explain, I hope, the interest and the sense of relation I developed as these drawings progressed.

Gary Walters

Hastings, Ontario

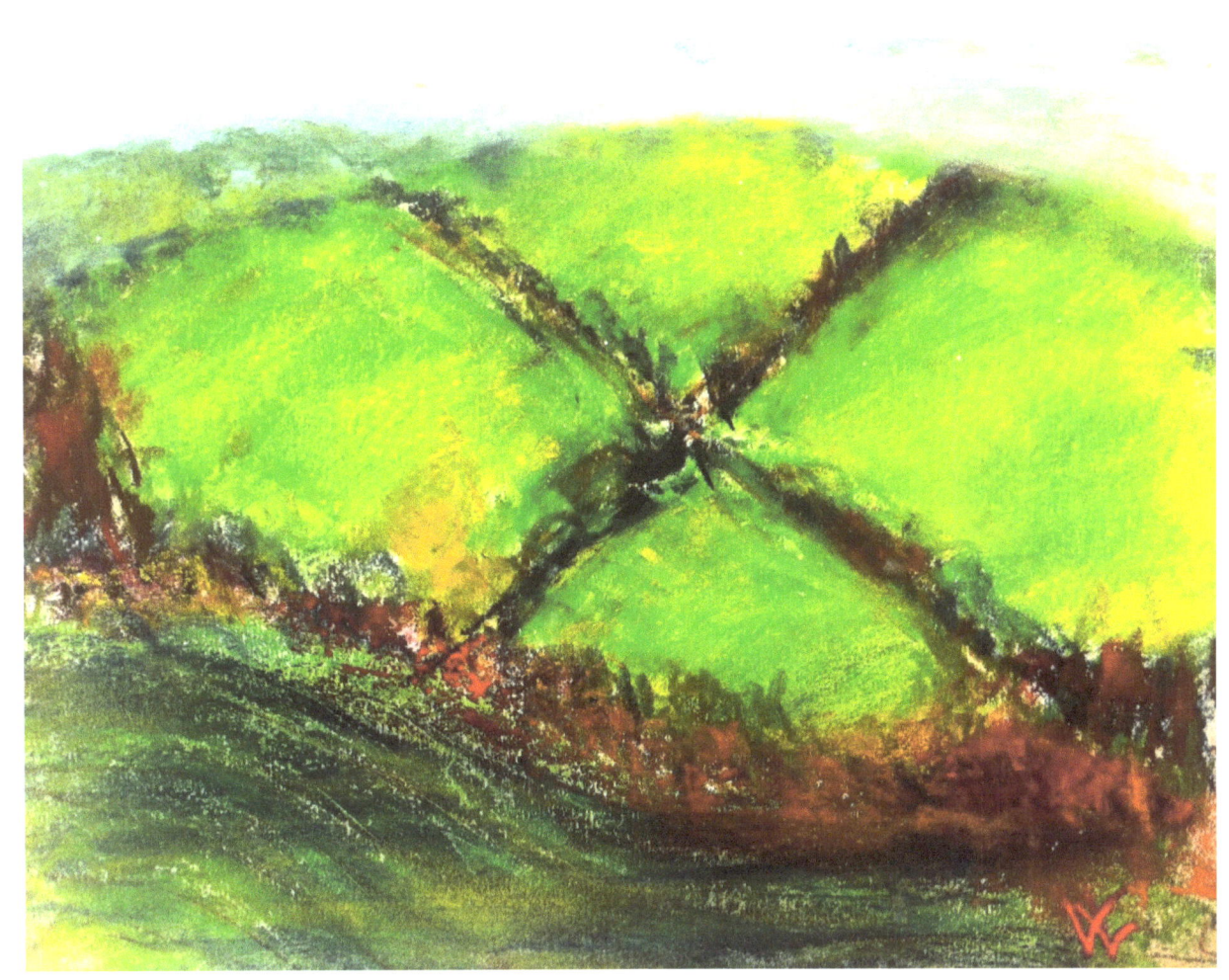

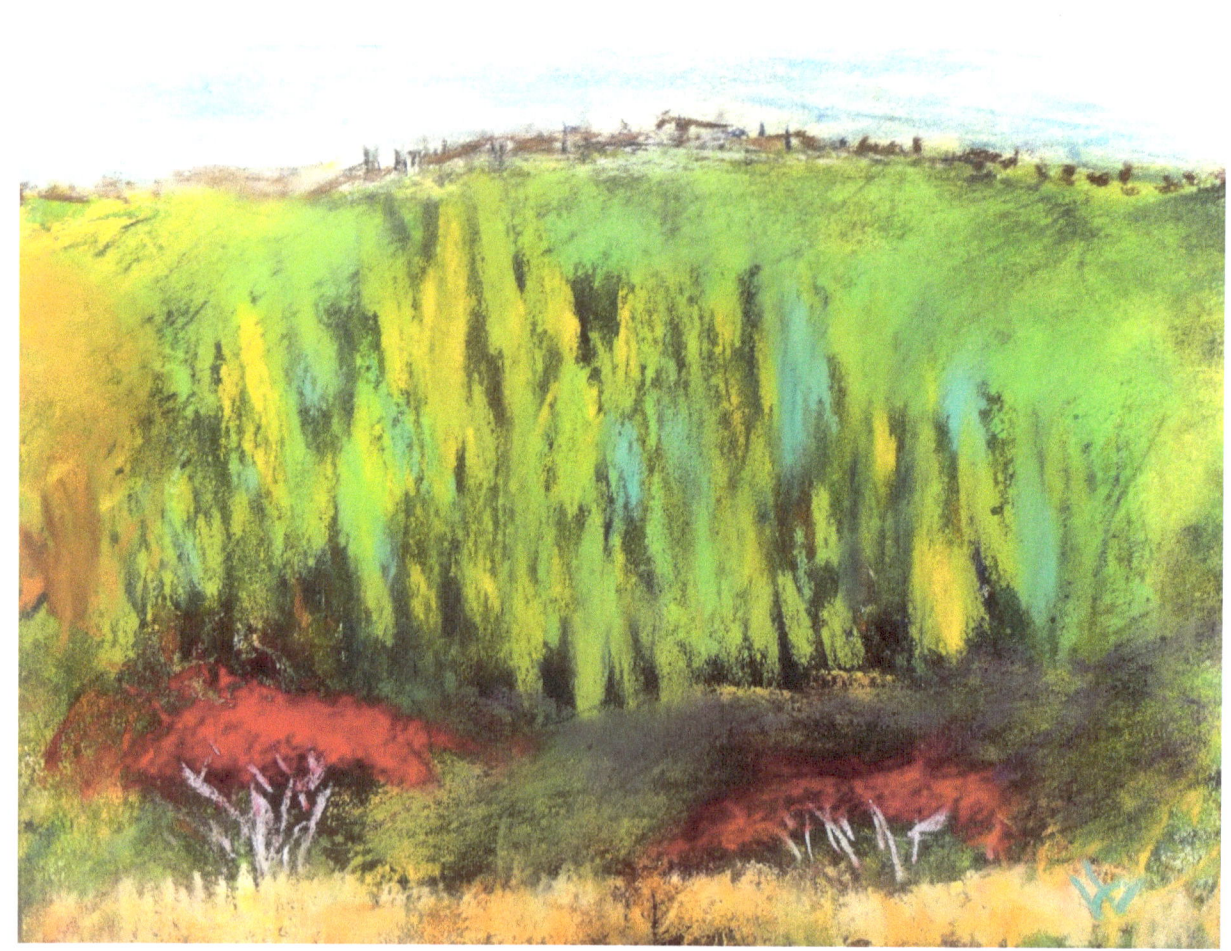

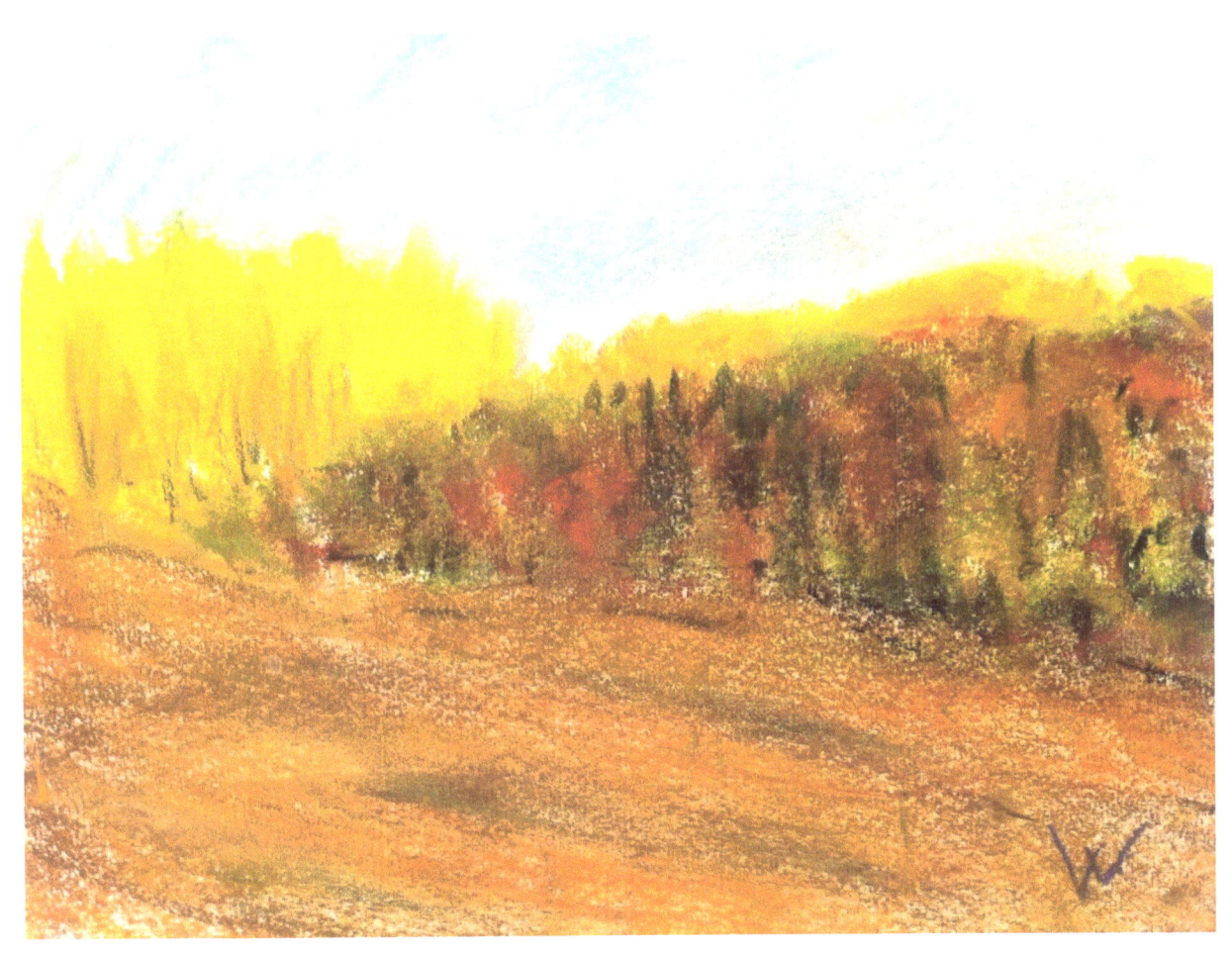

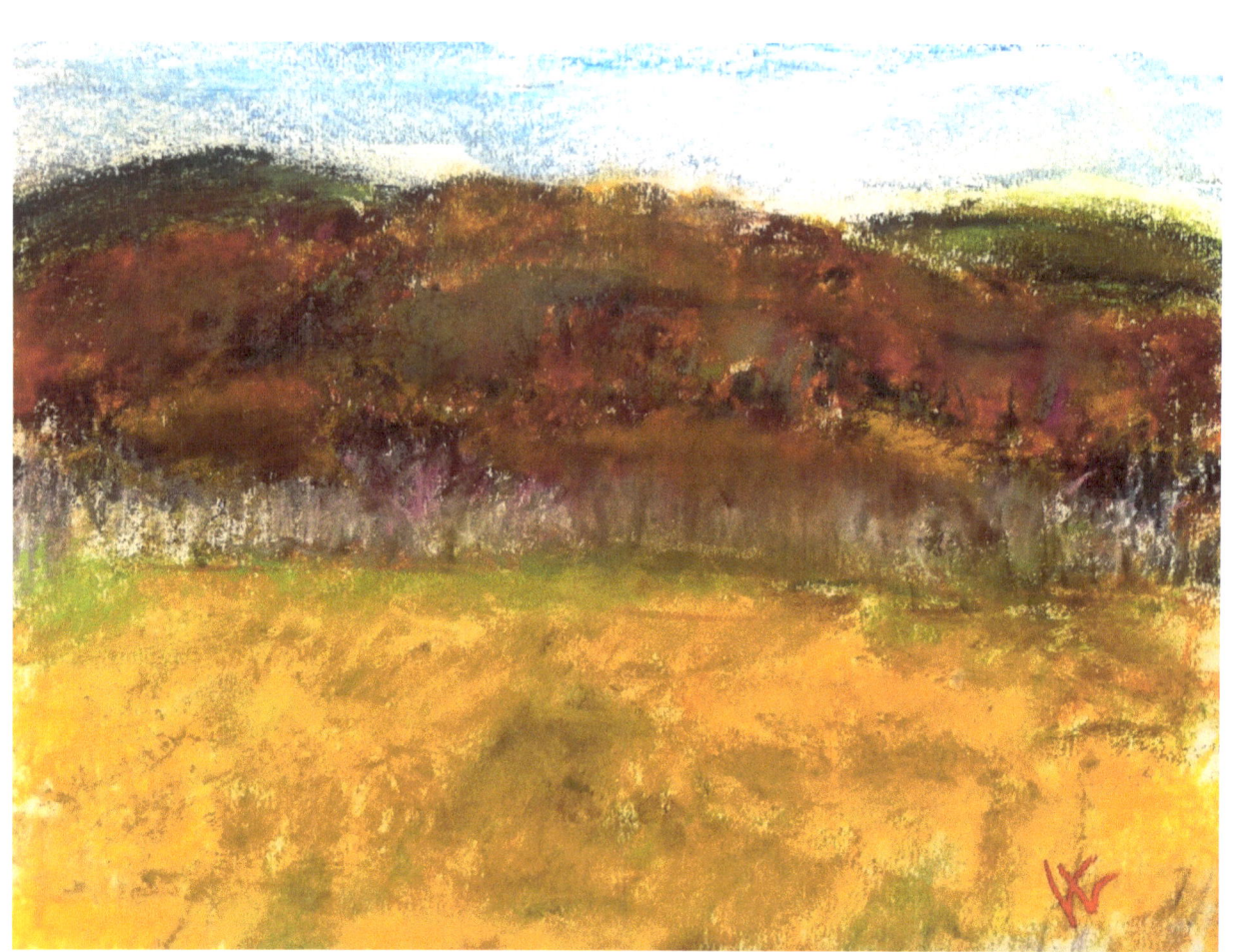

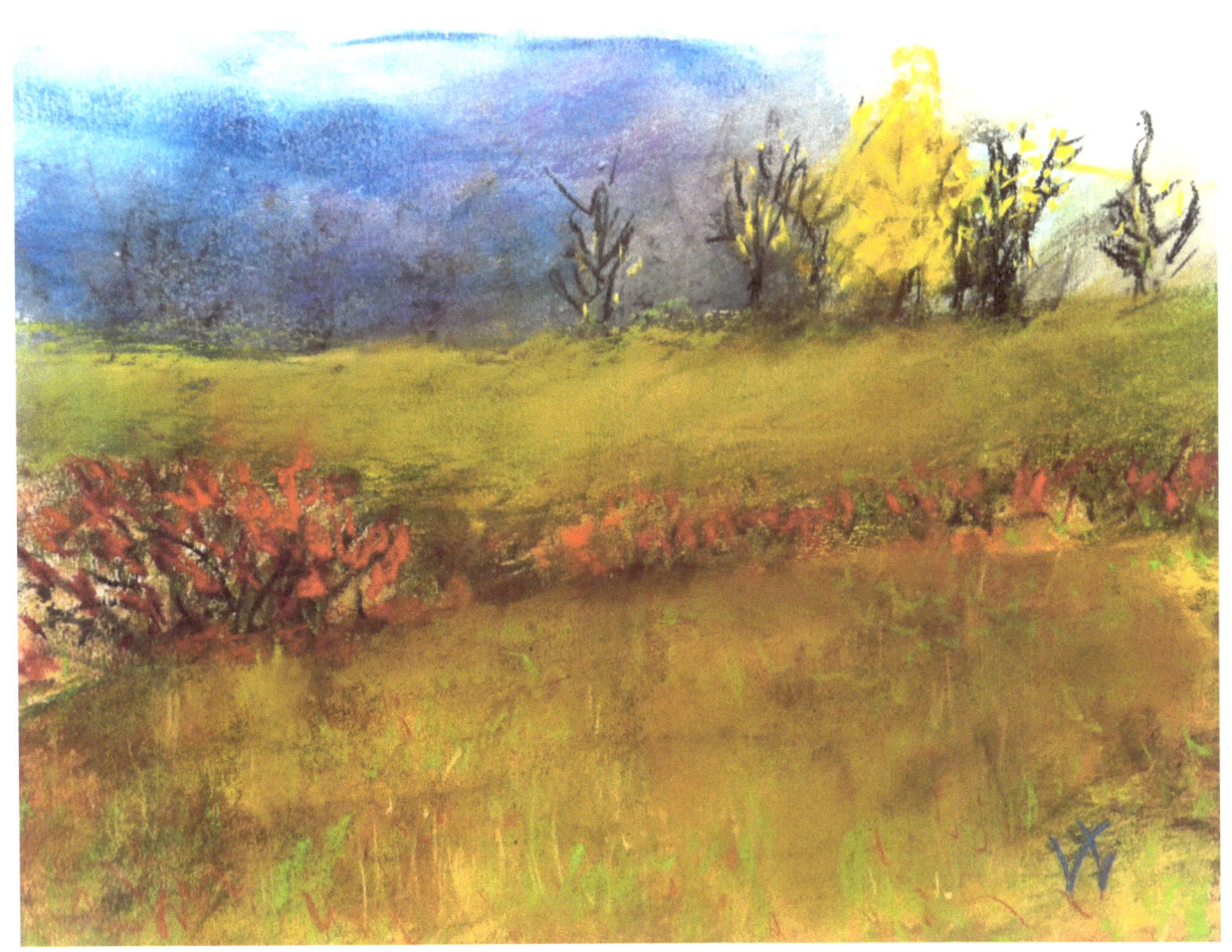

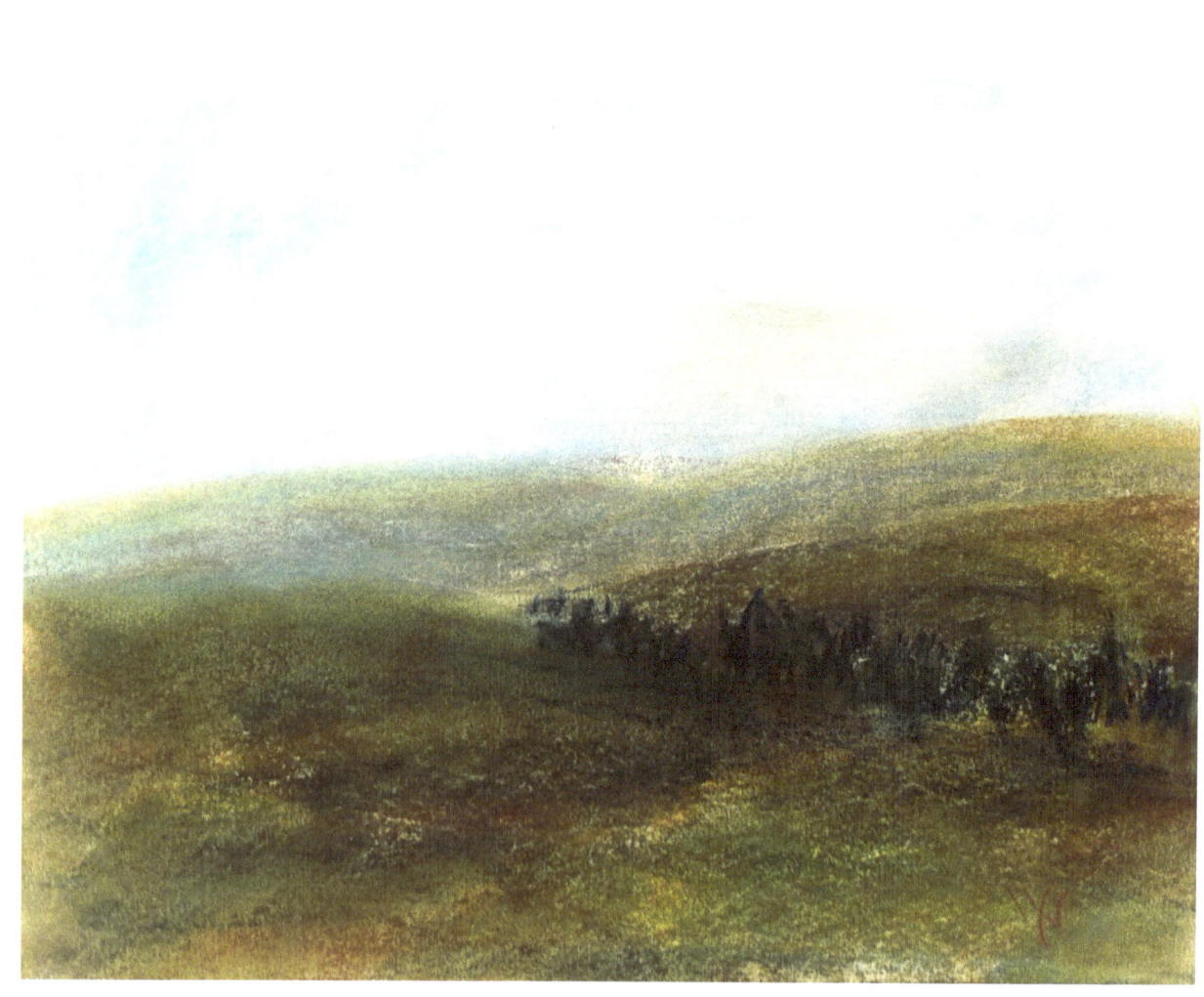

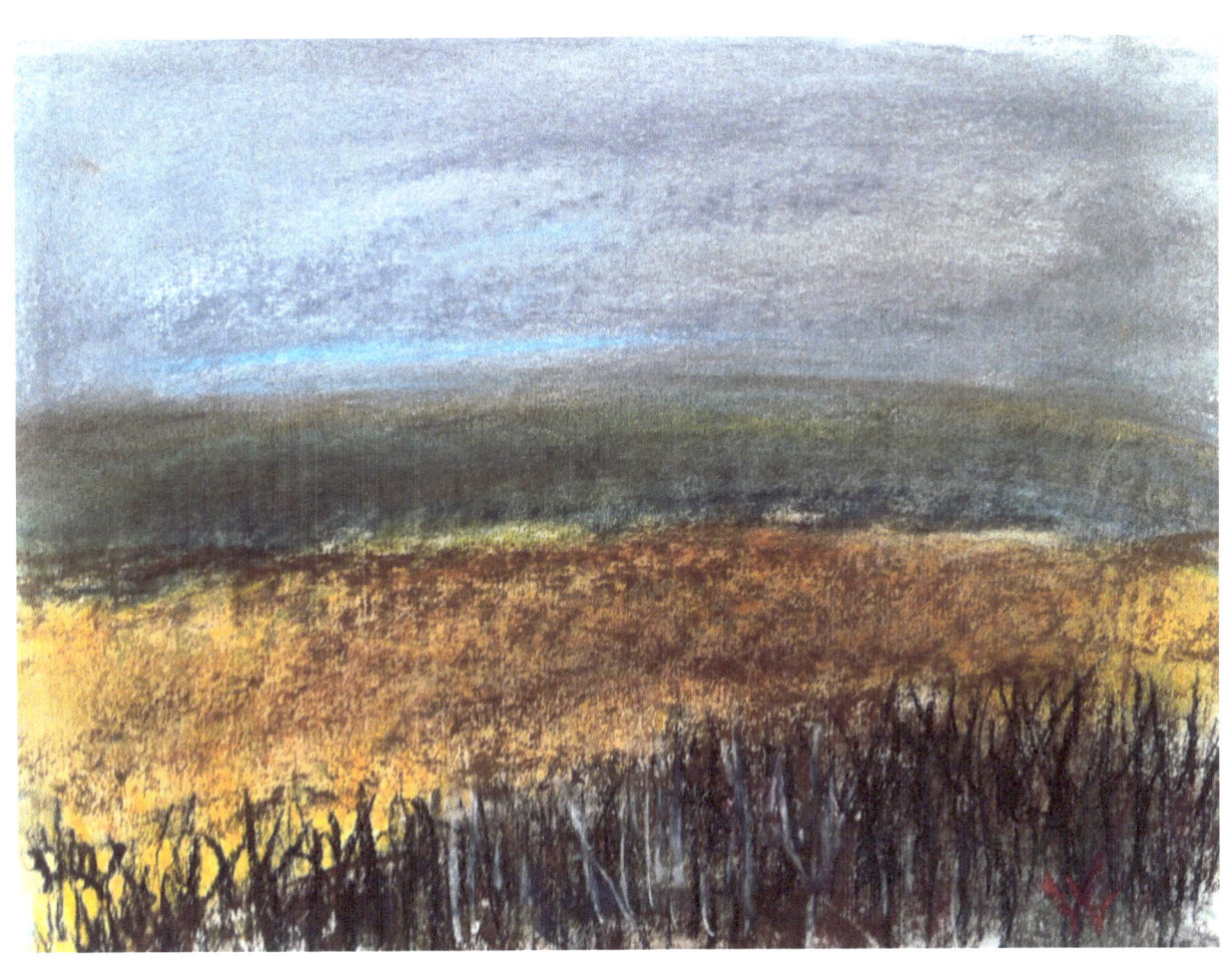

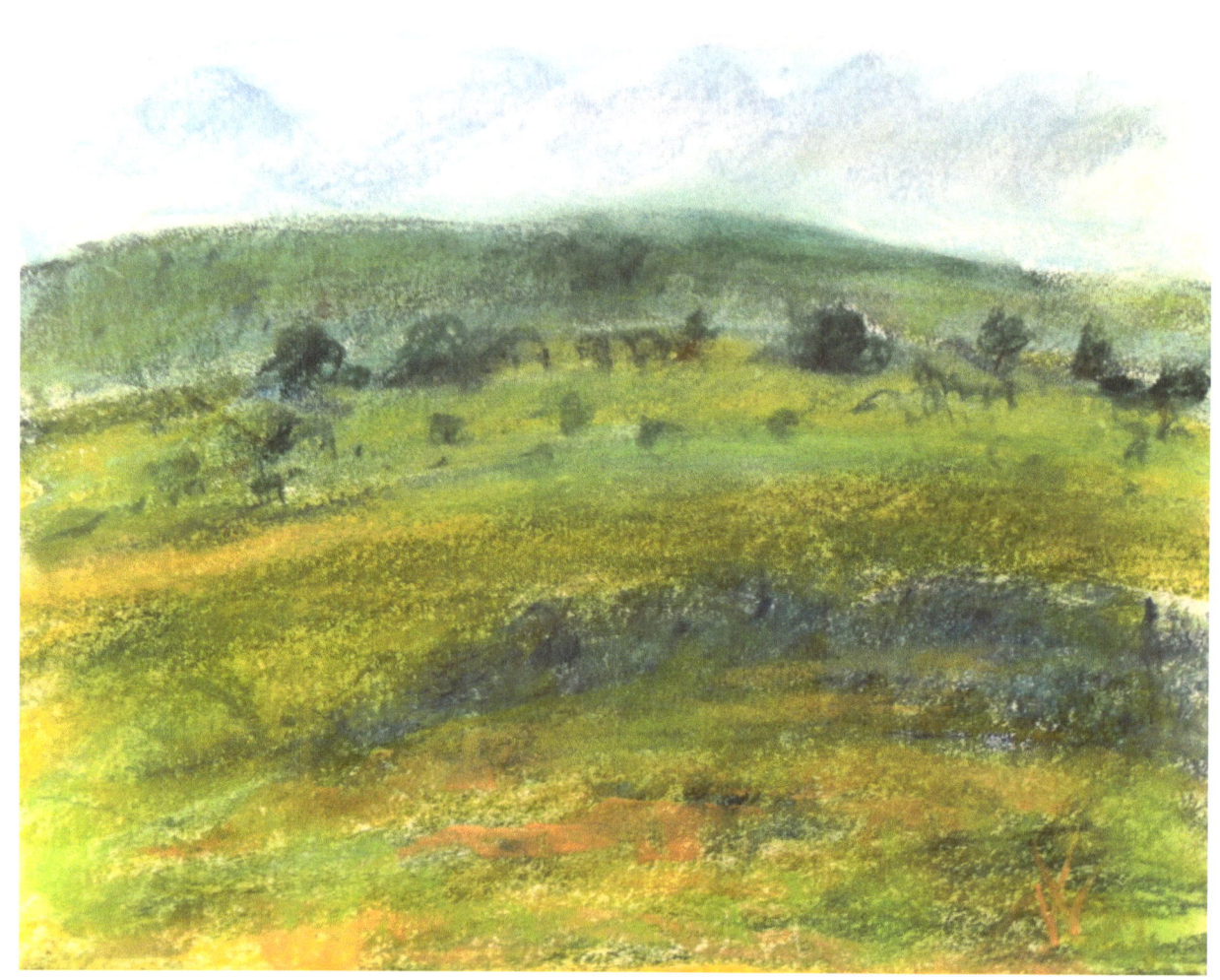

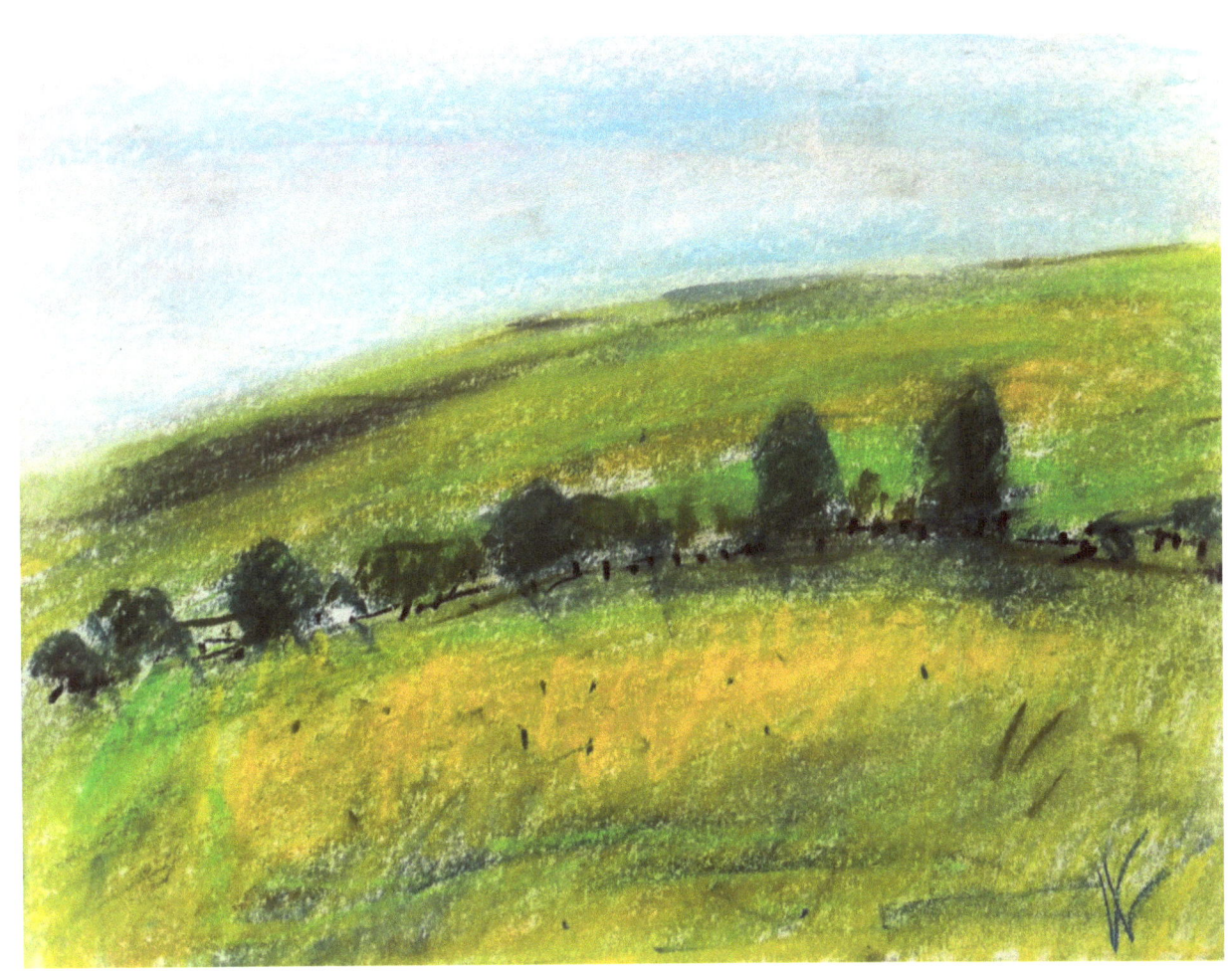

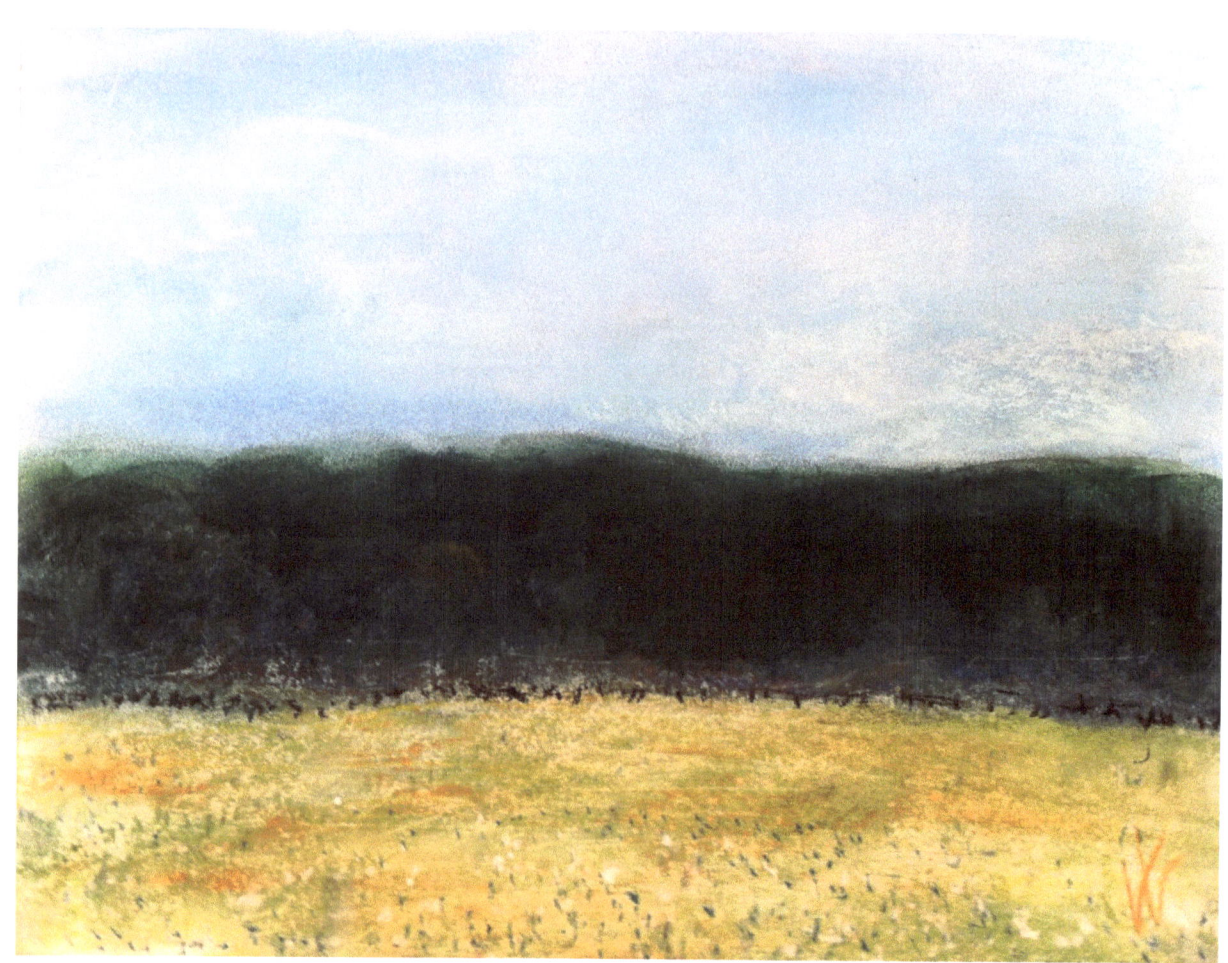

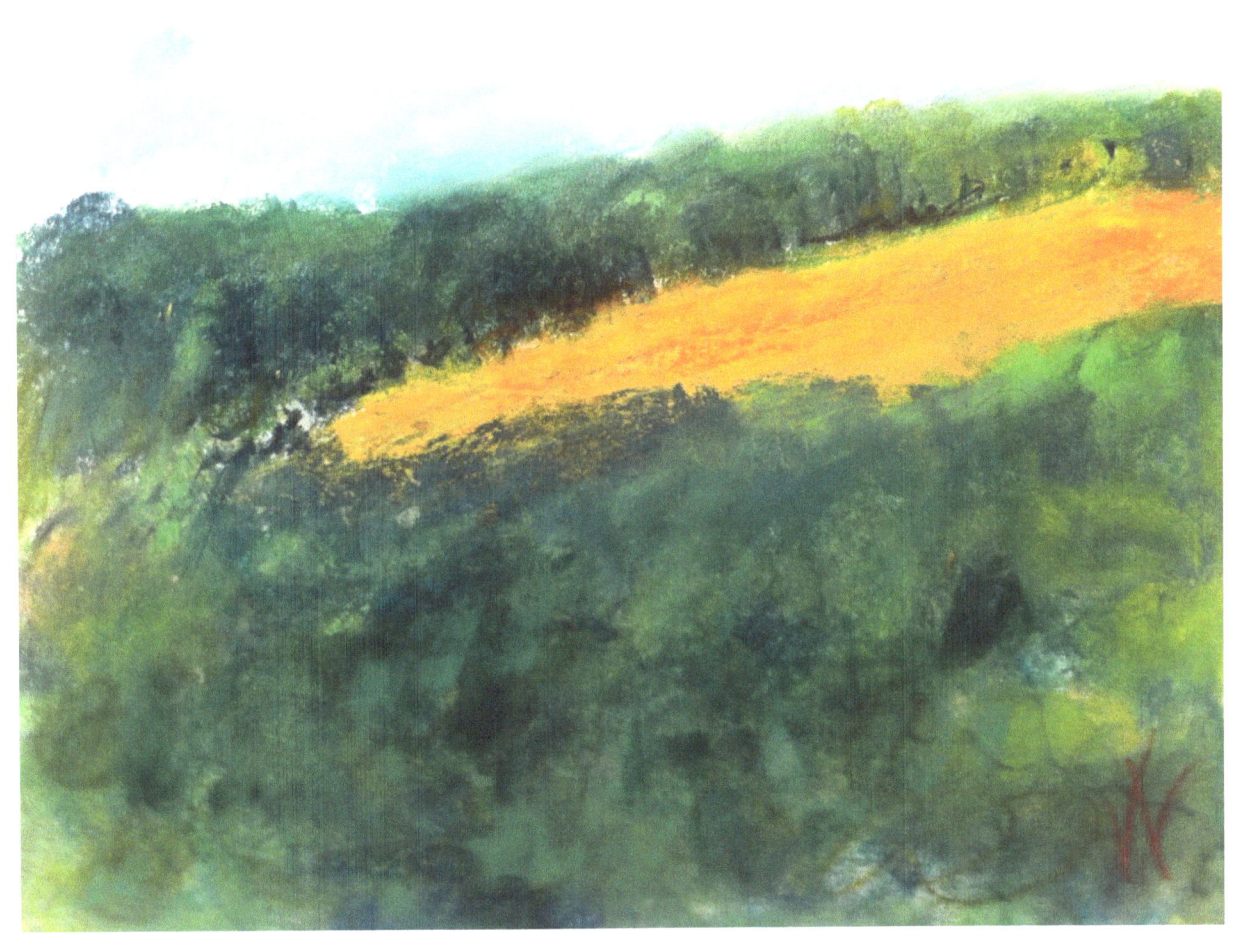

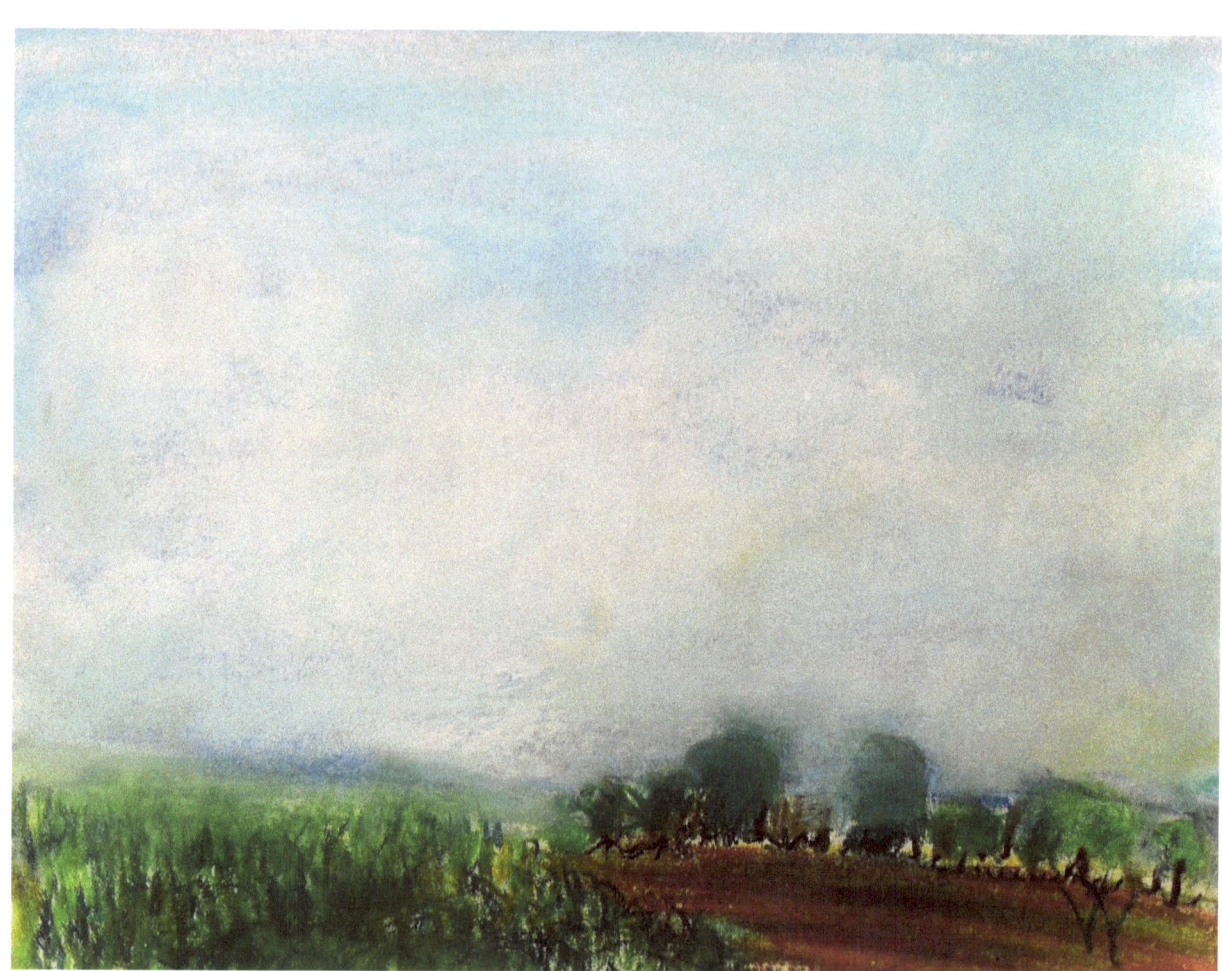

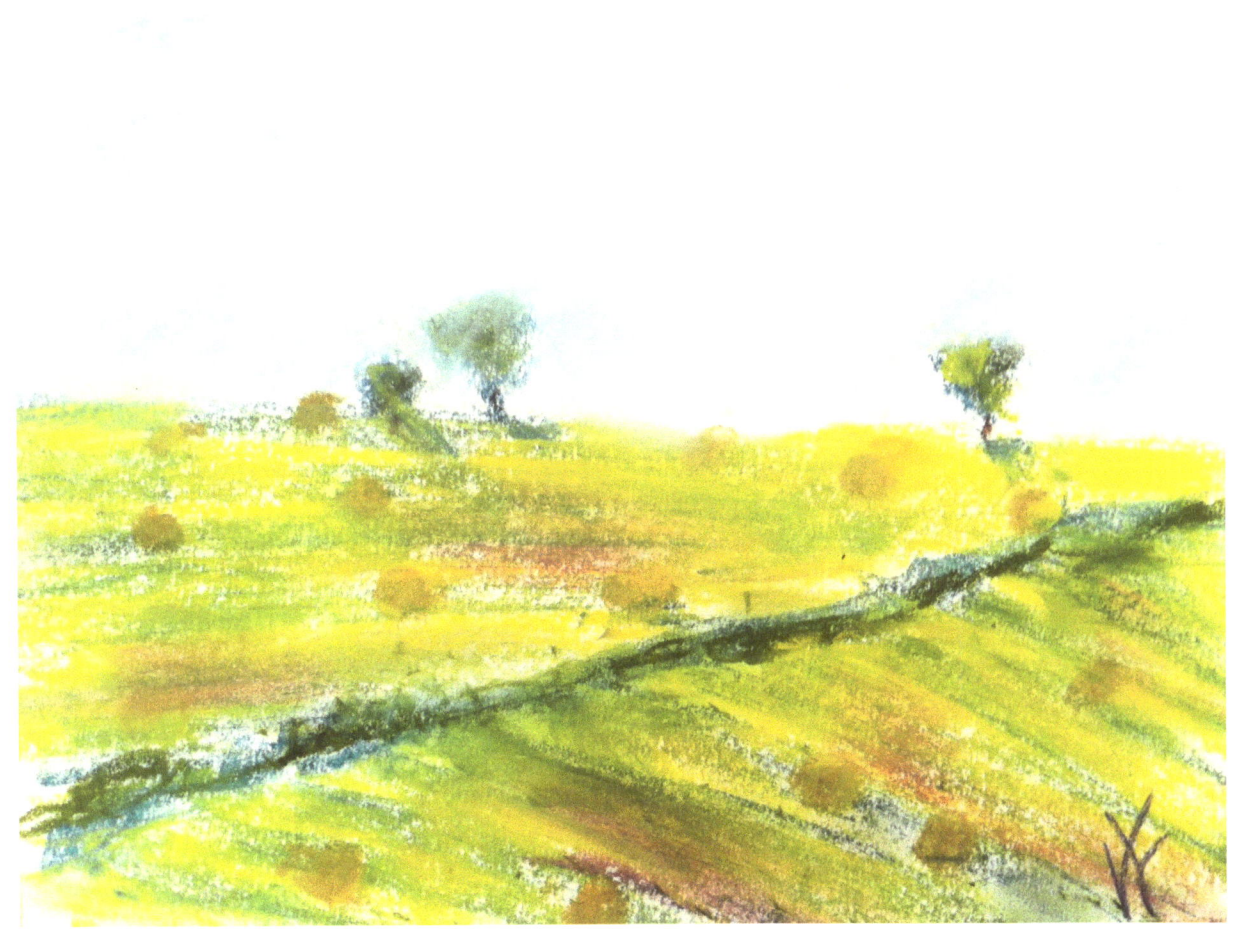

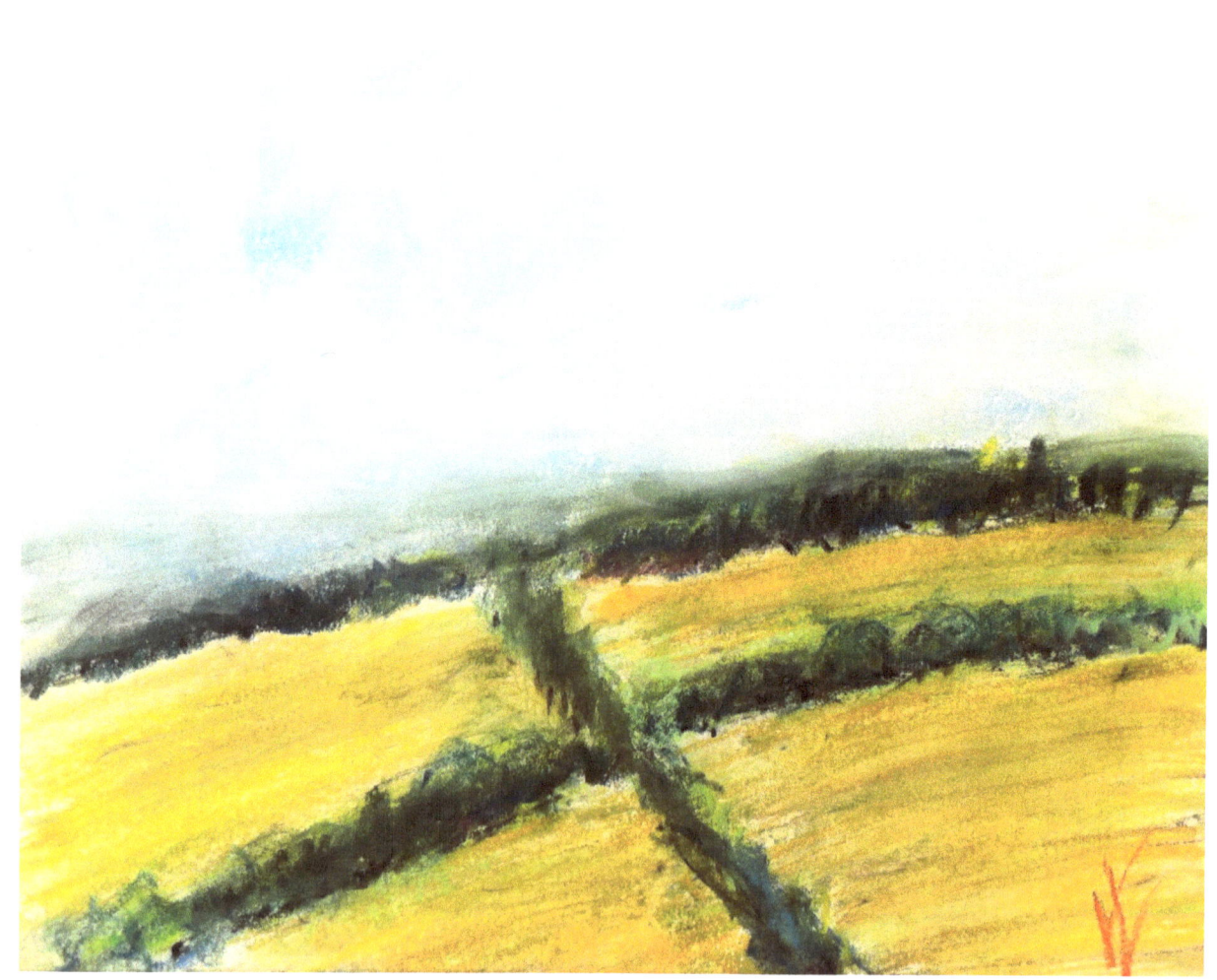

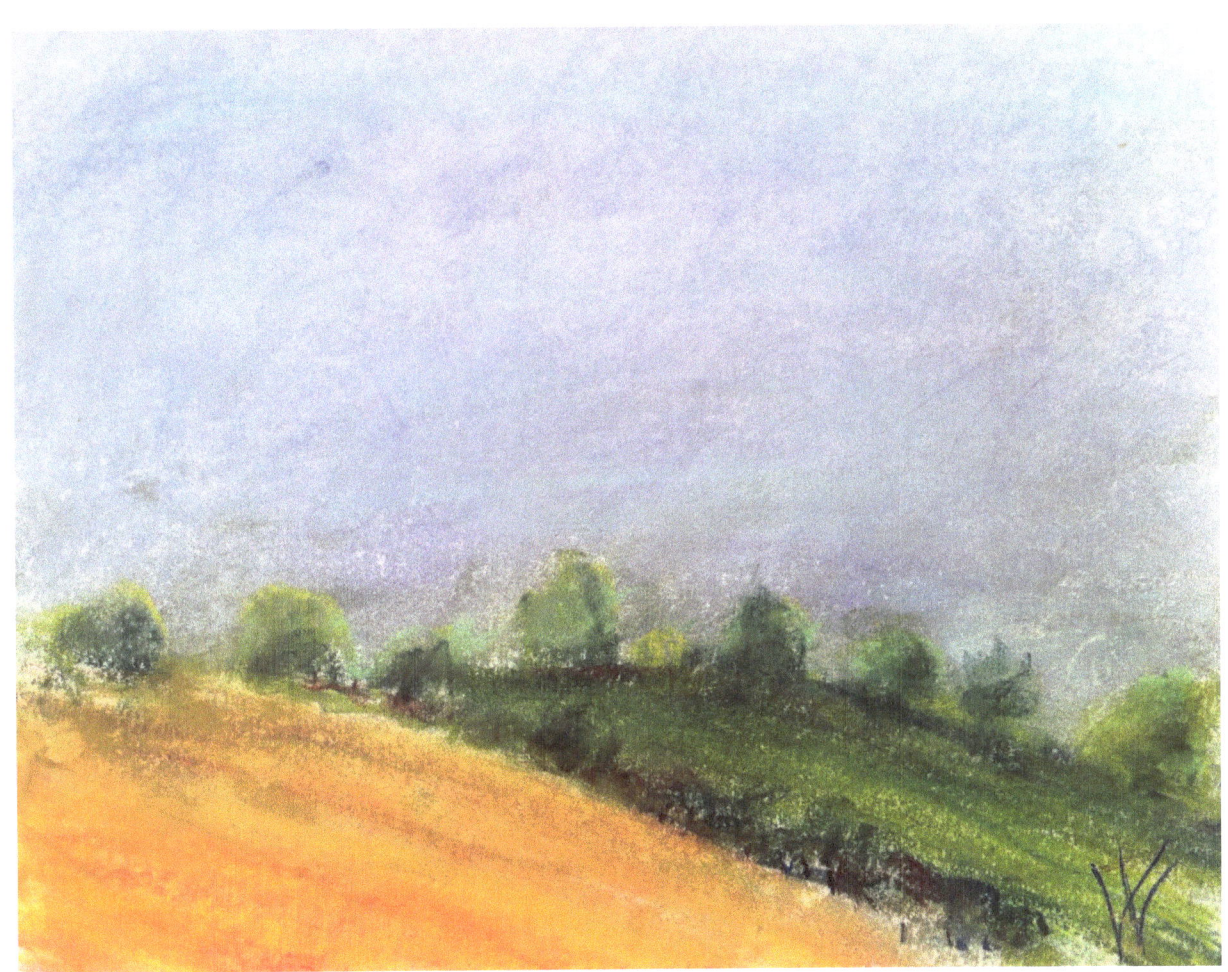

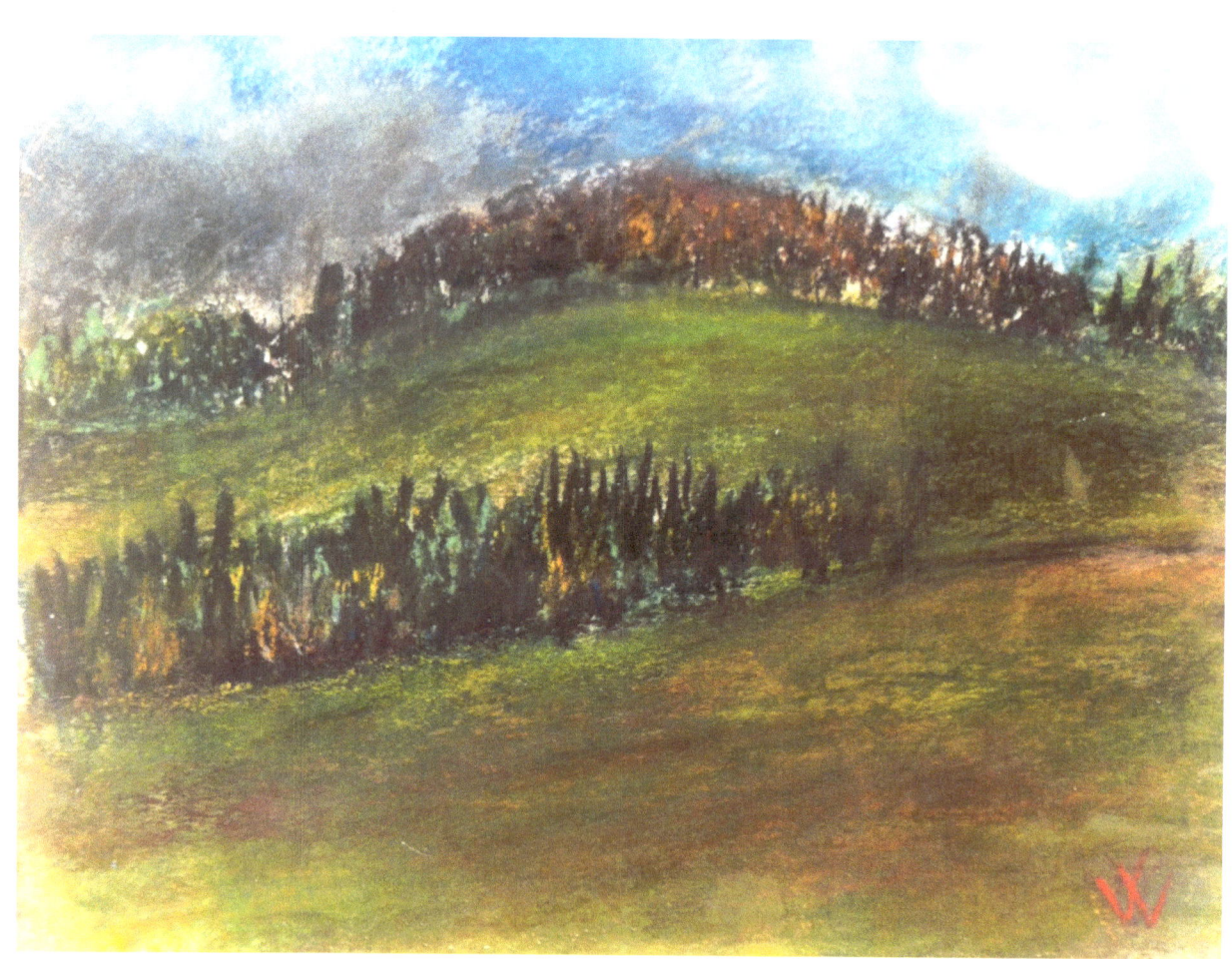

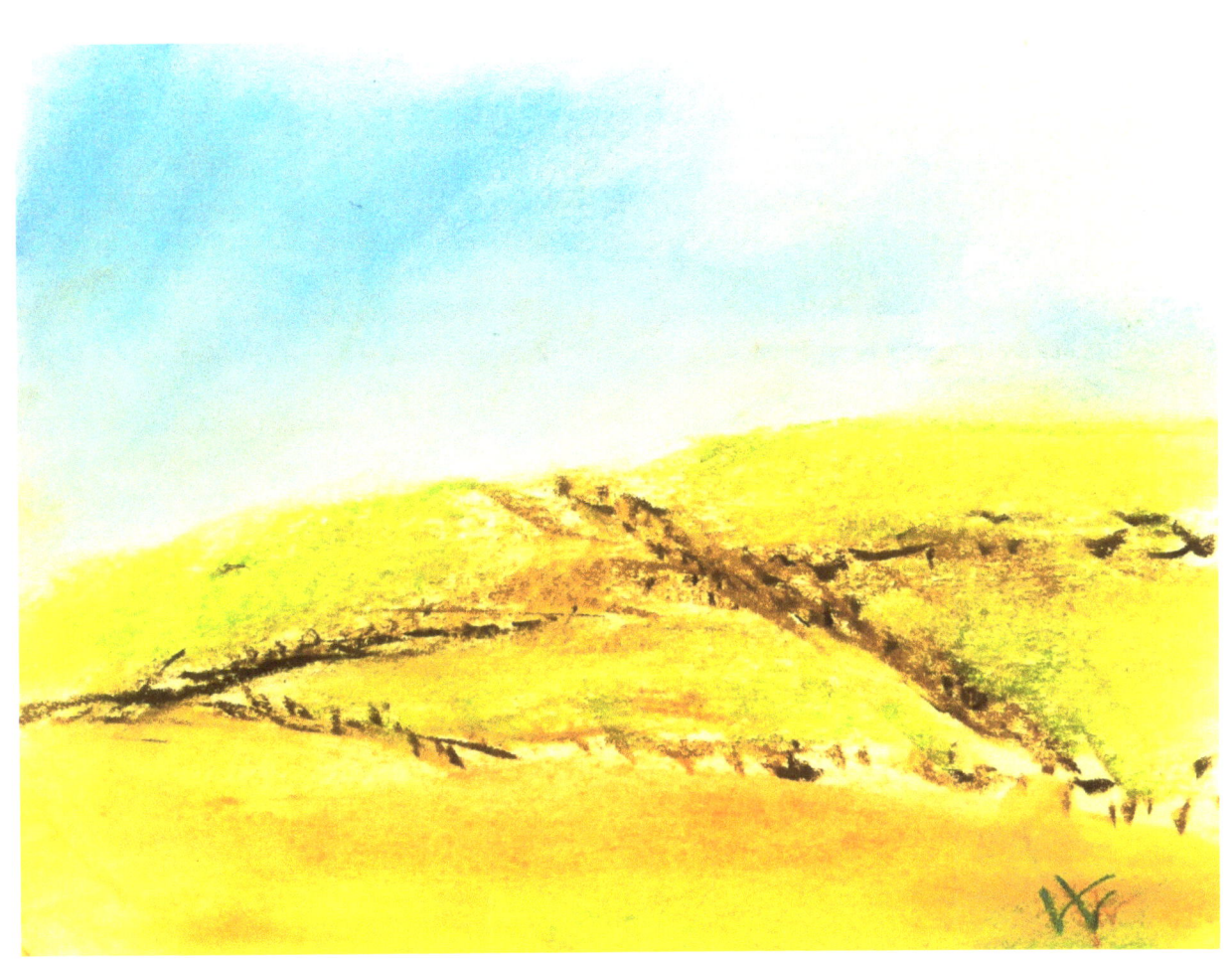

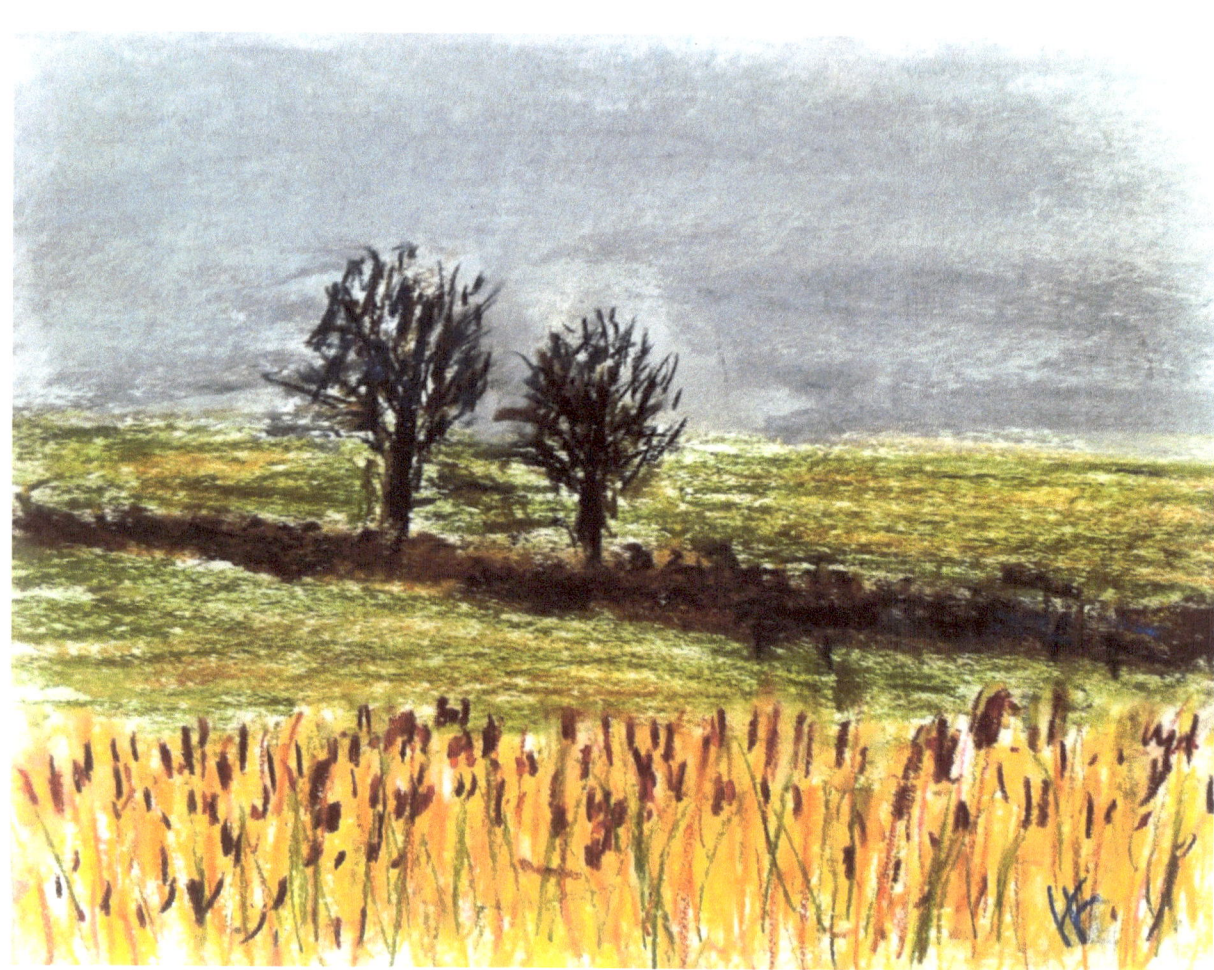

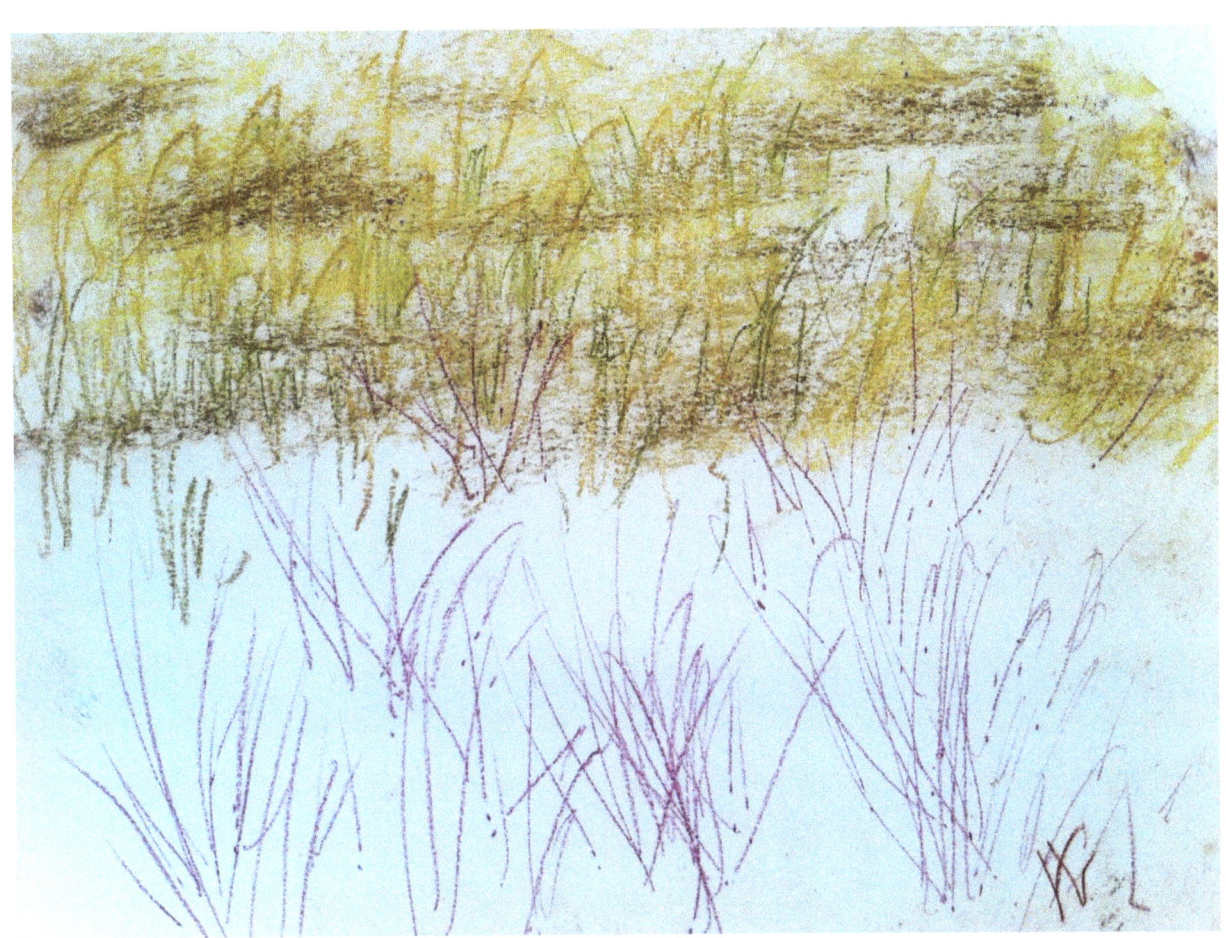

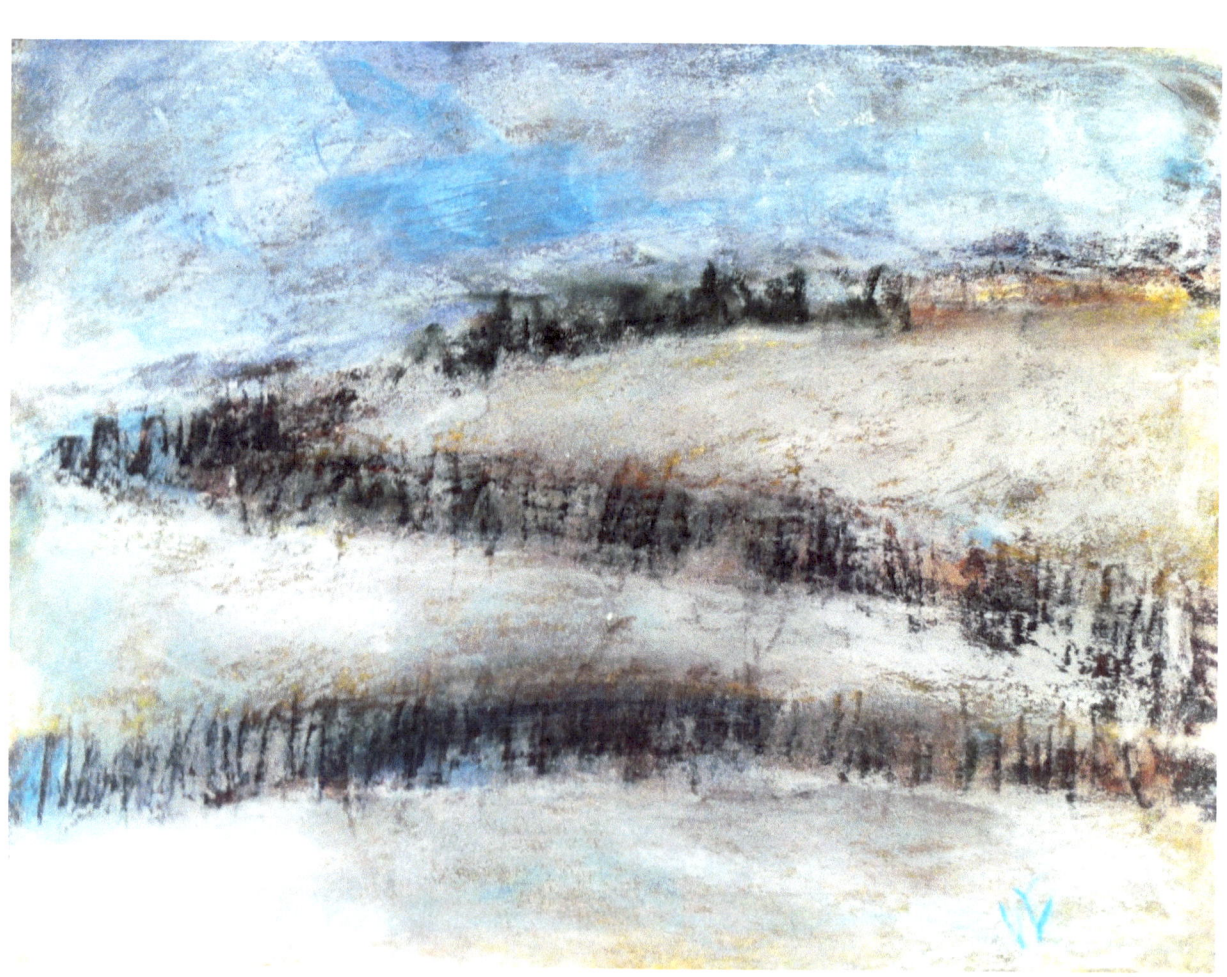

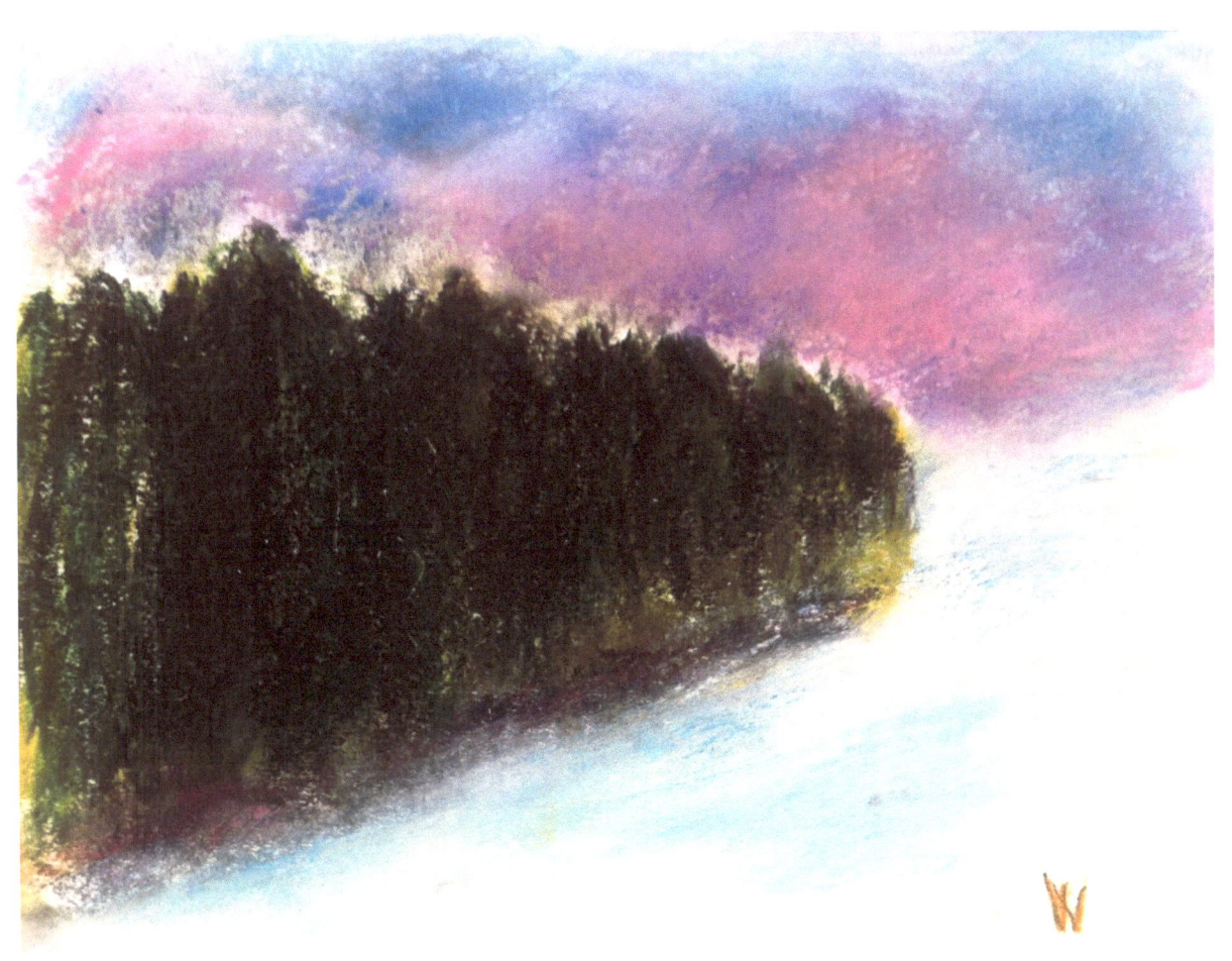

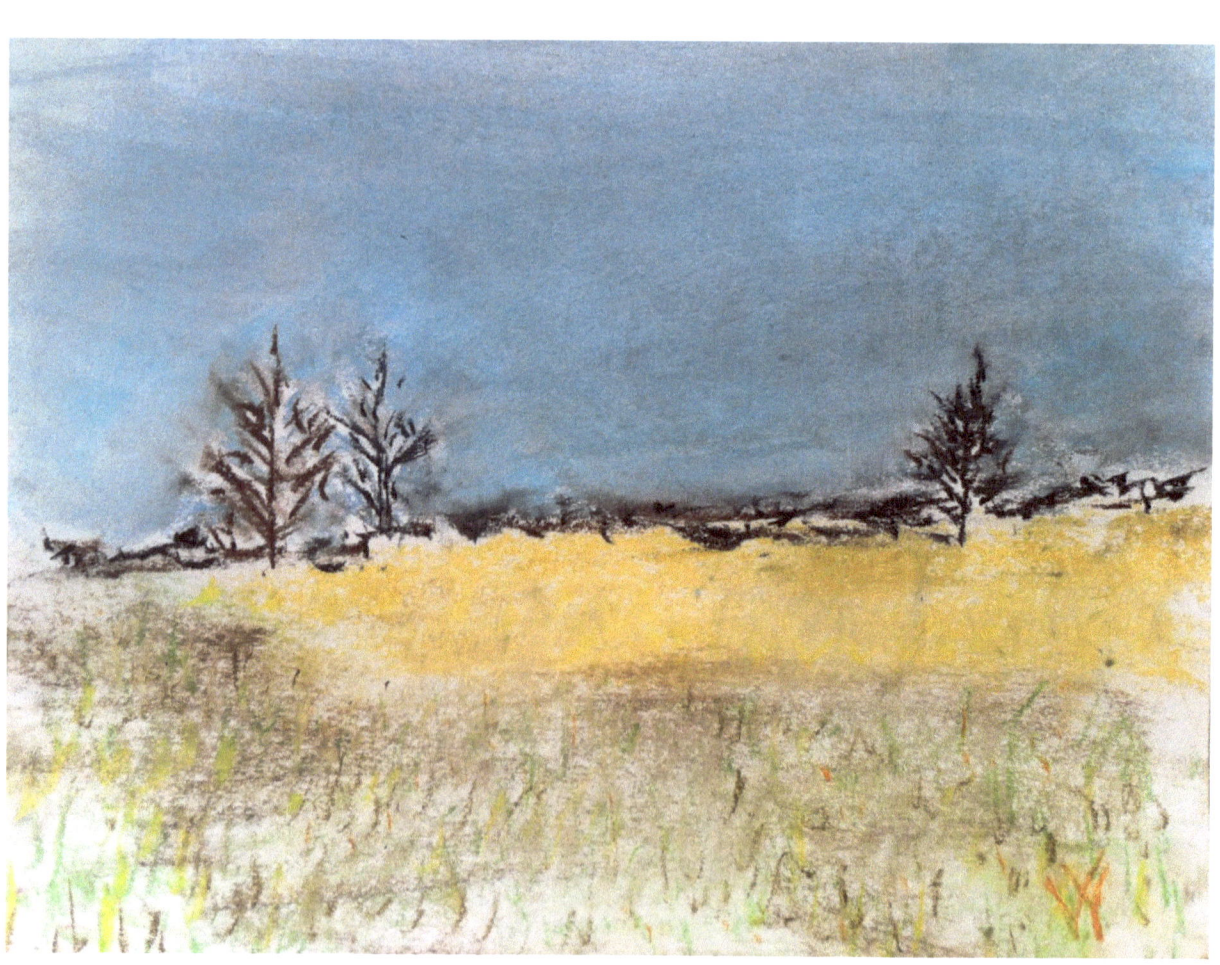

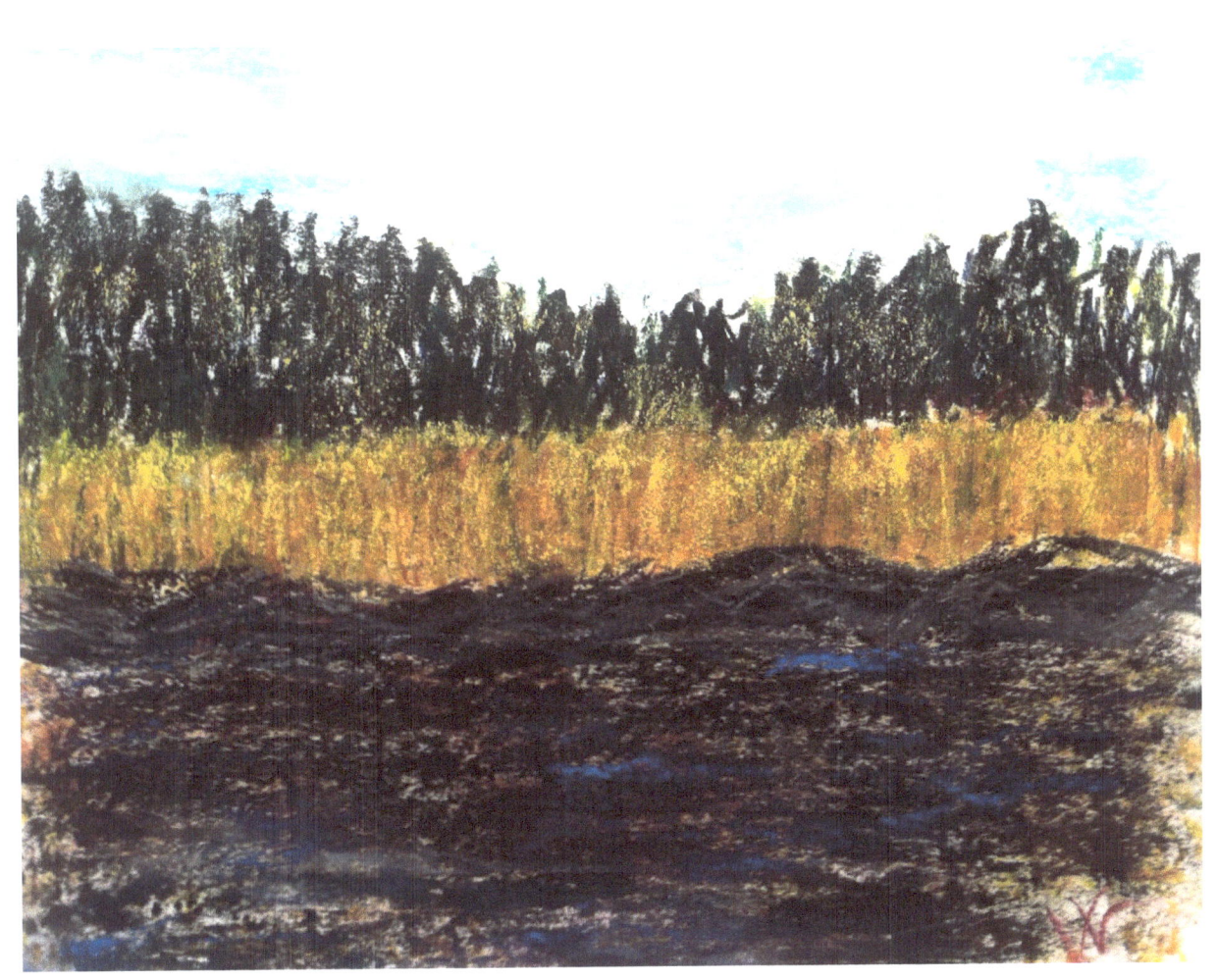

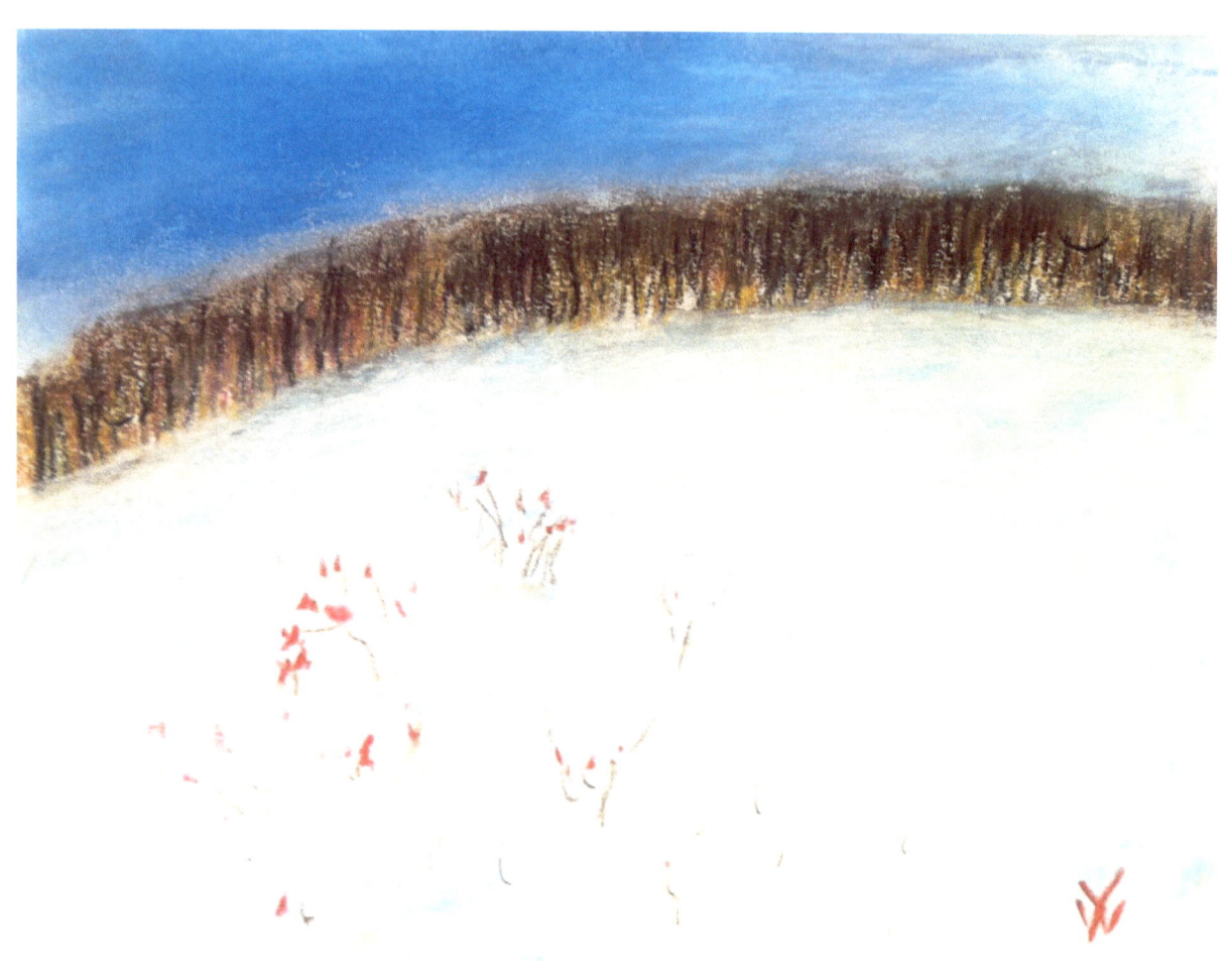

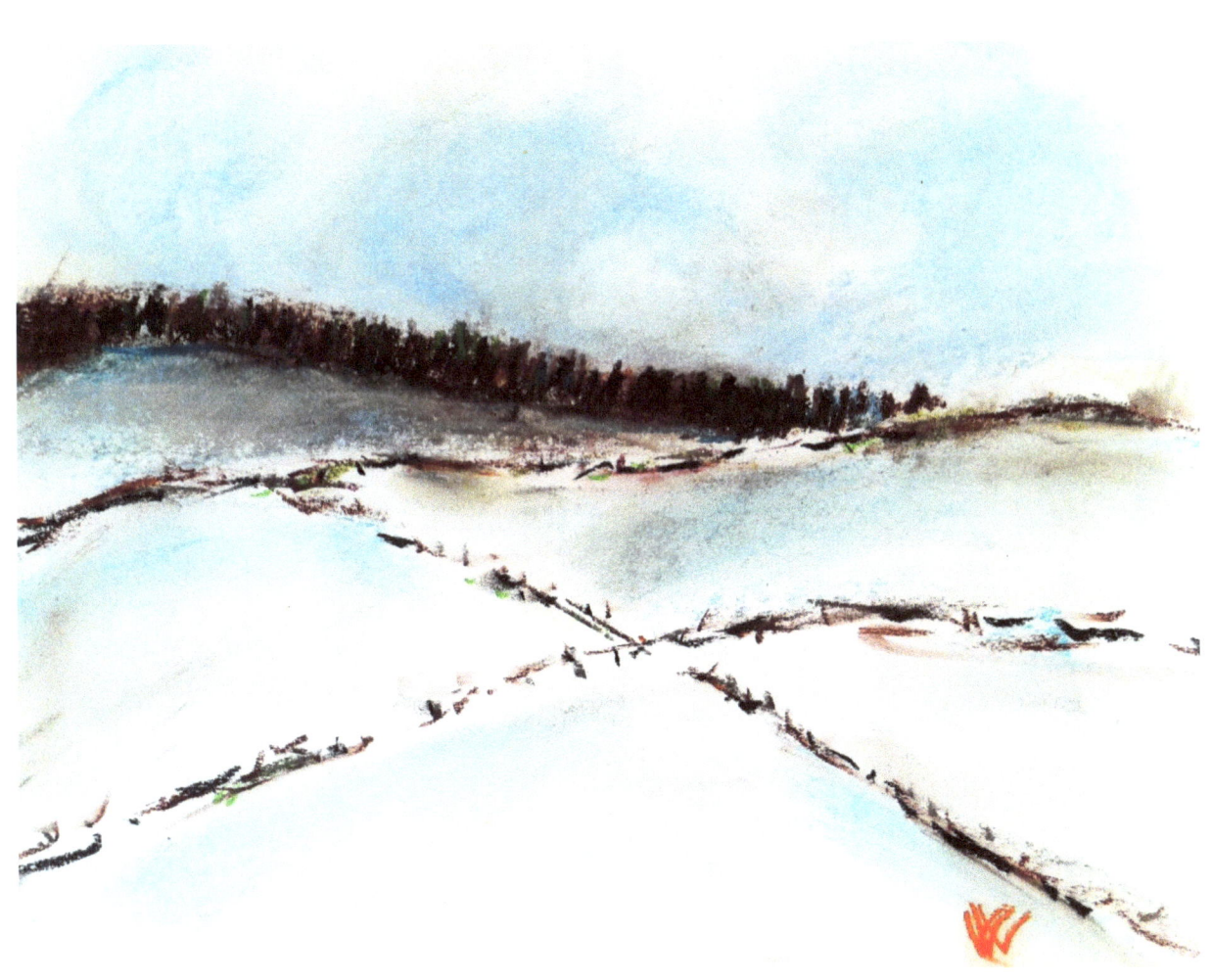

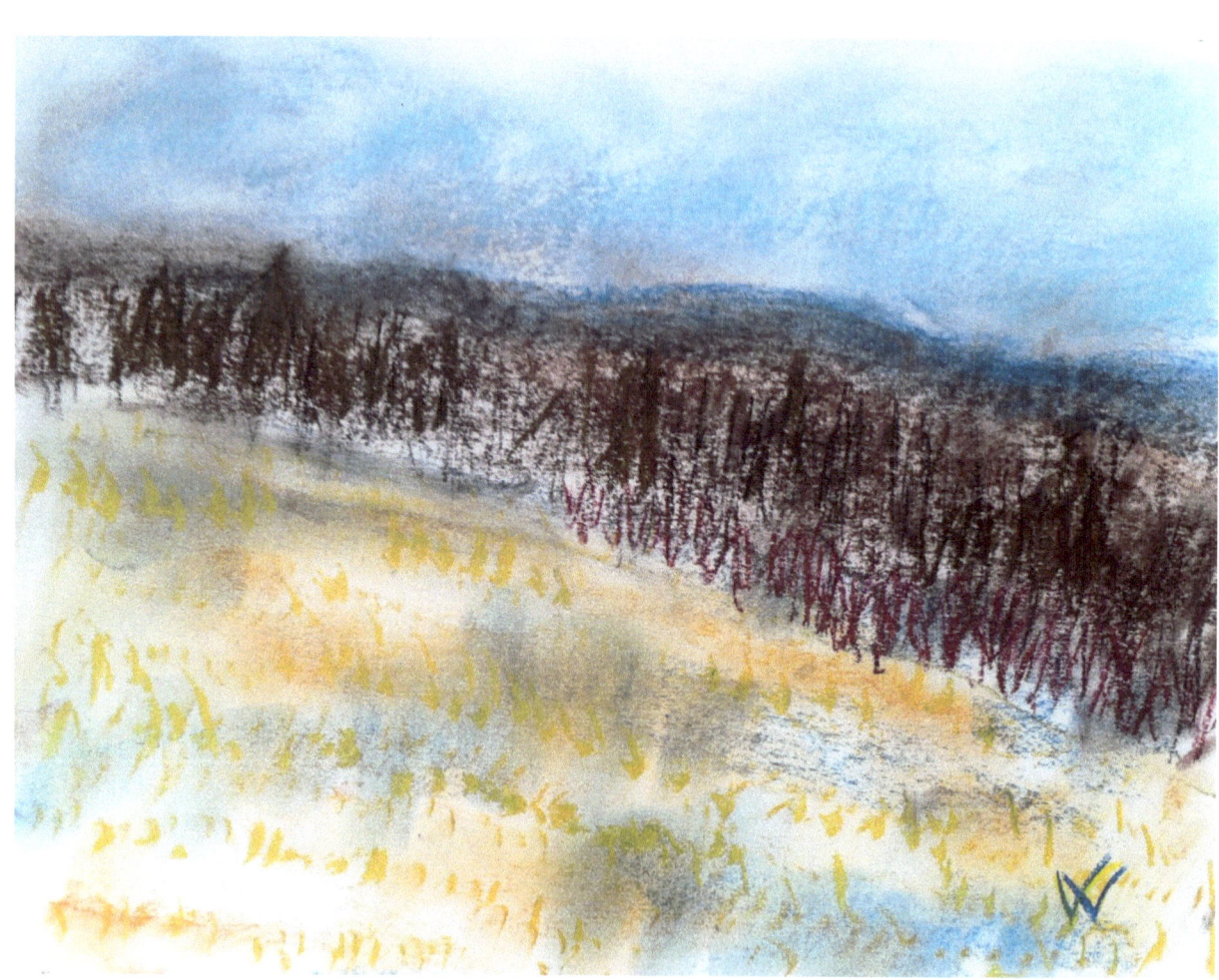

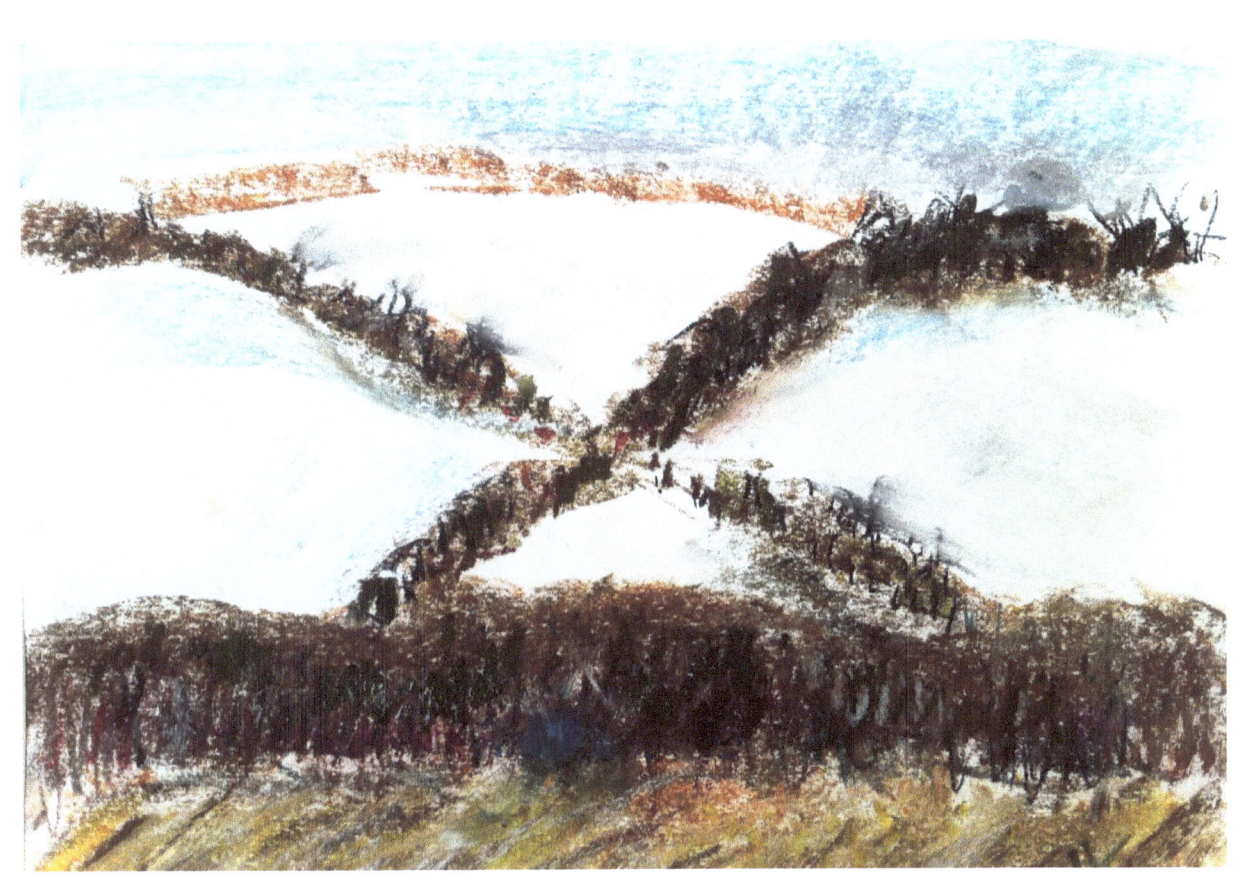

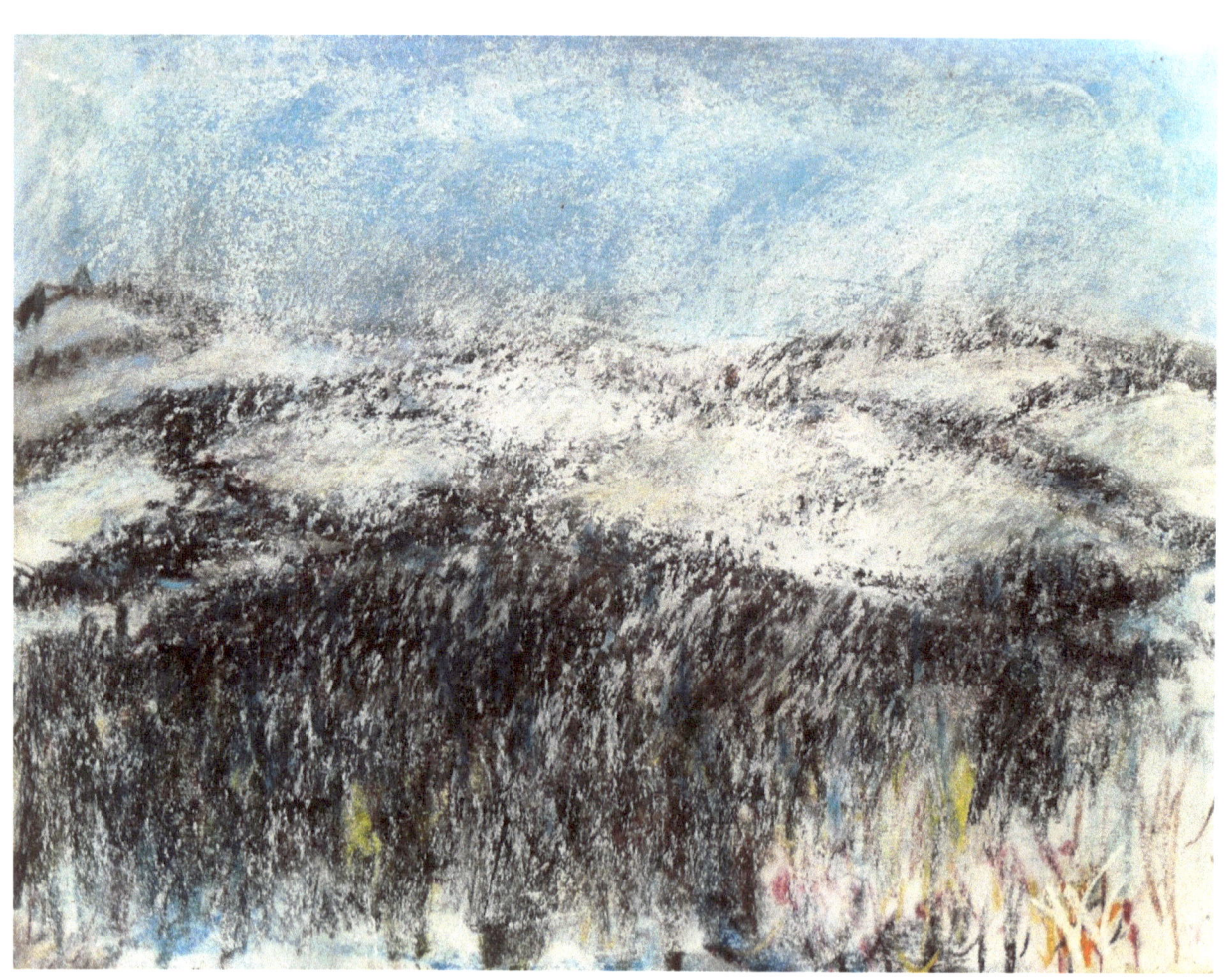

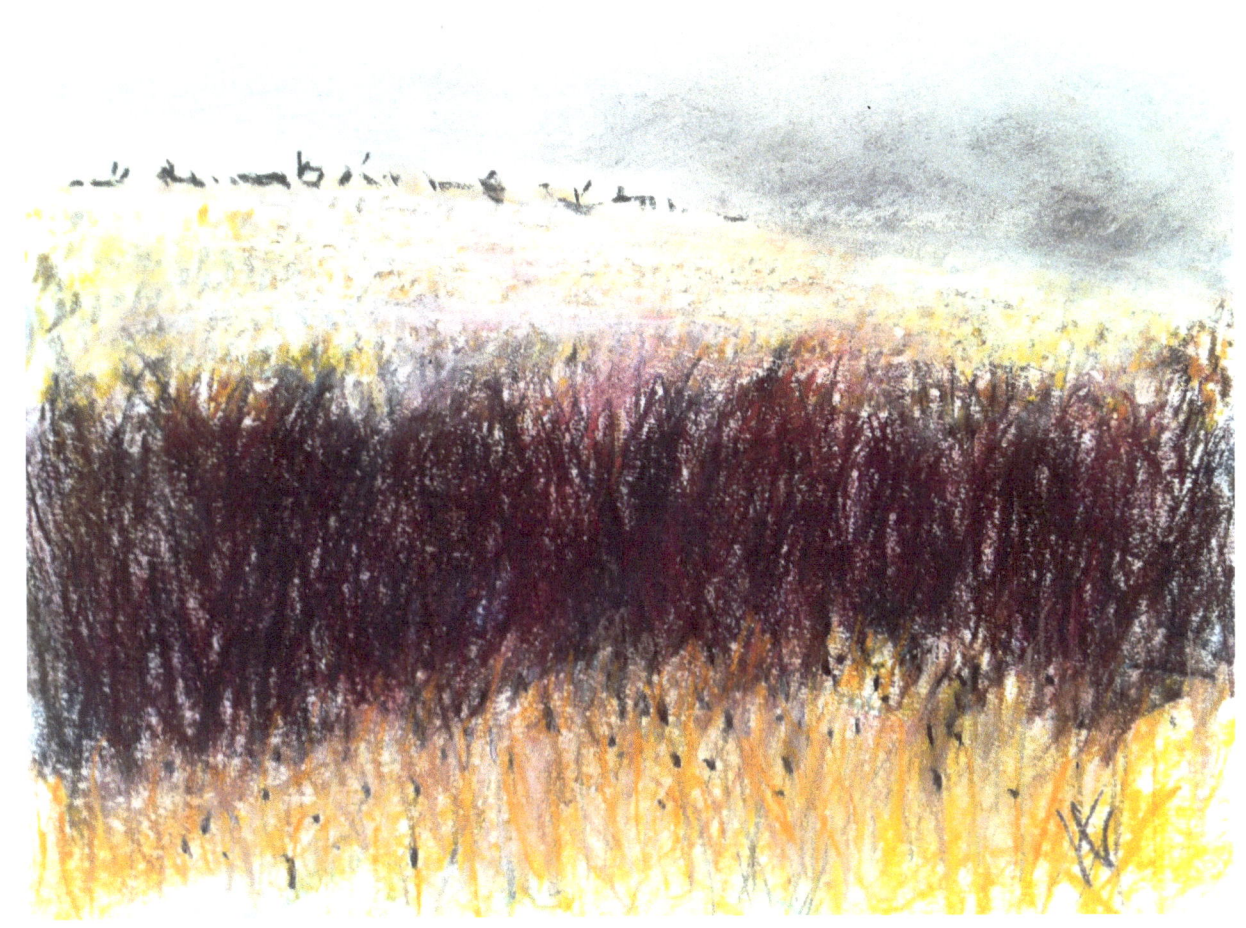

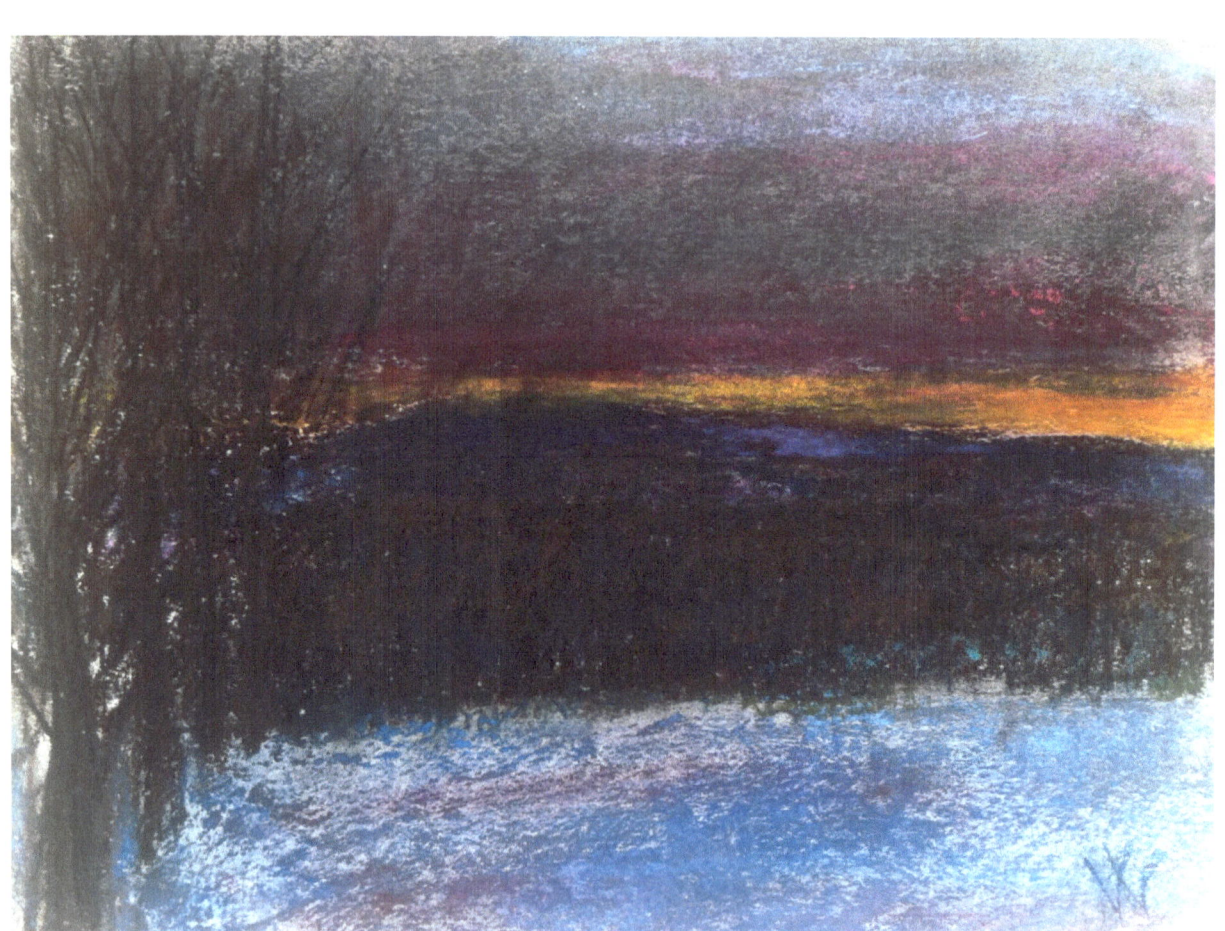

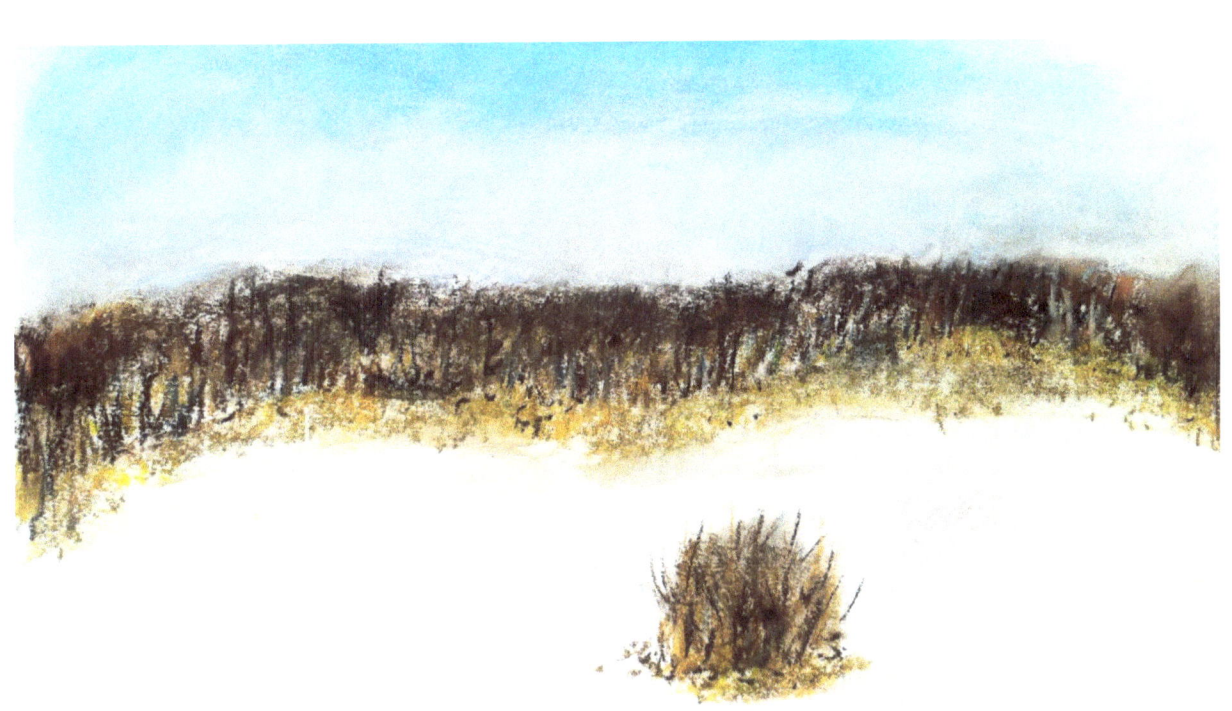

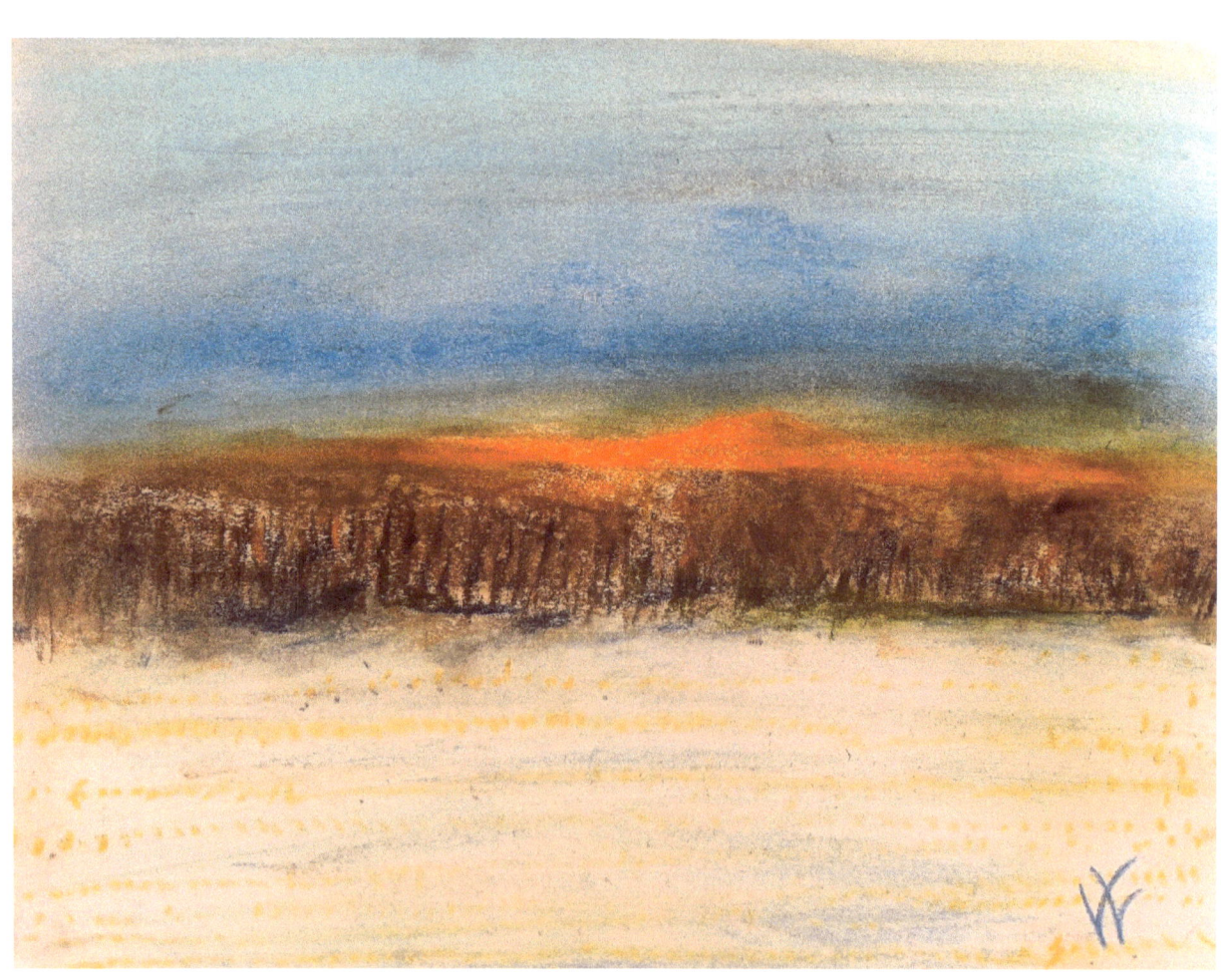

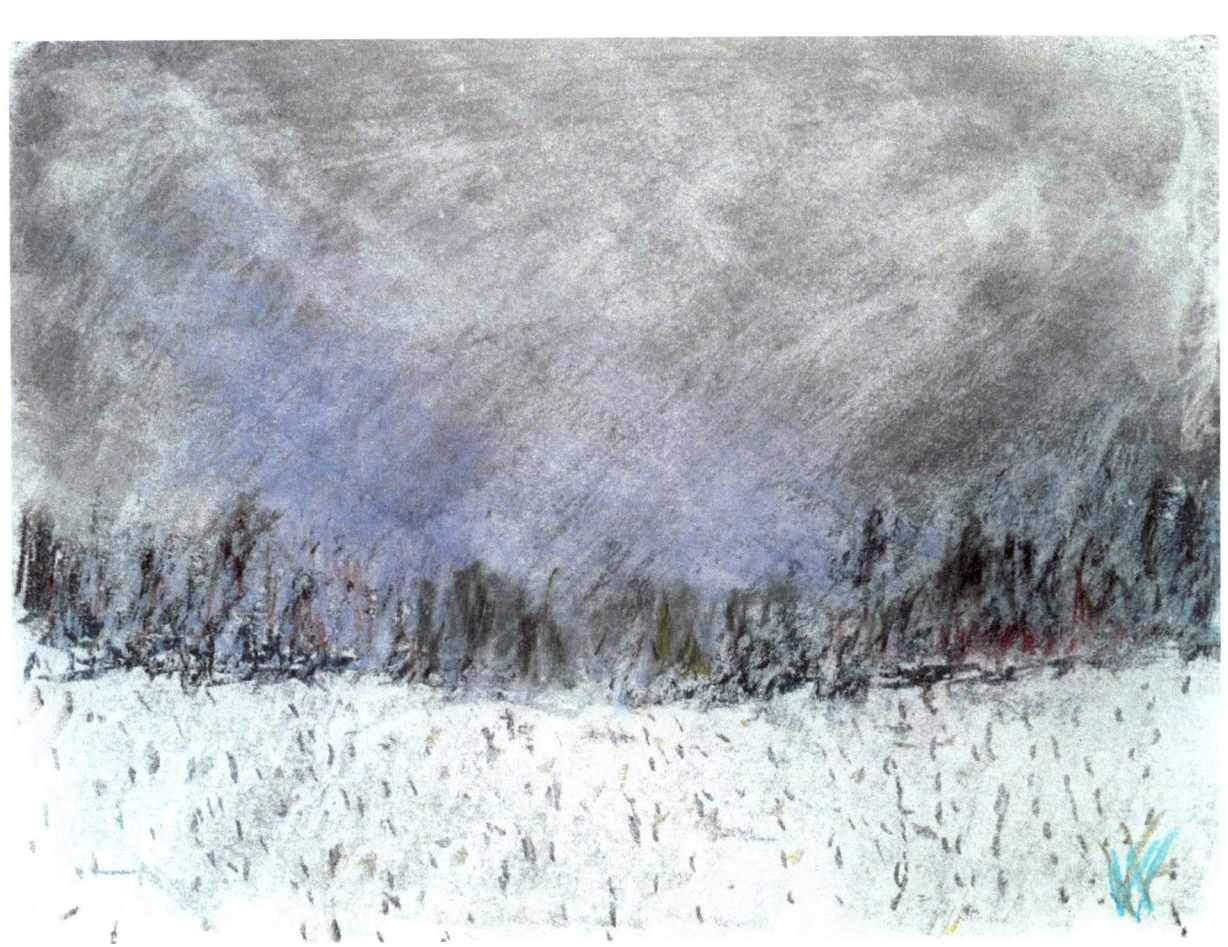

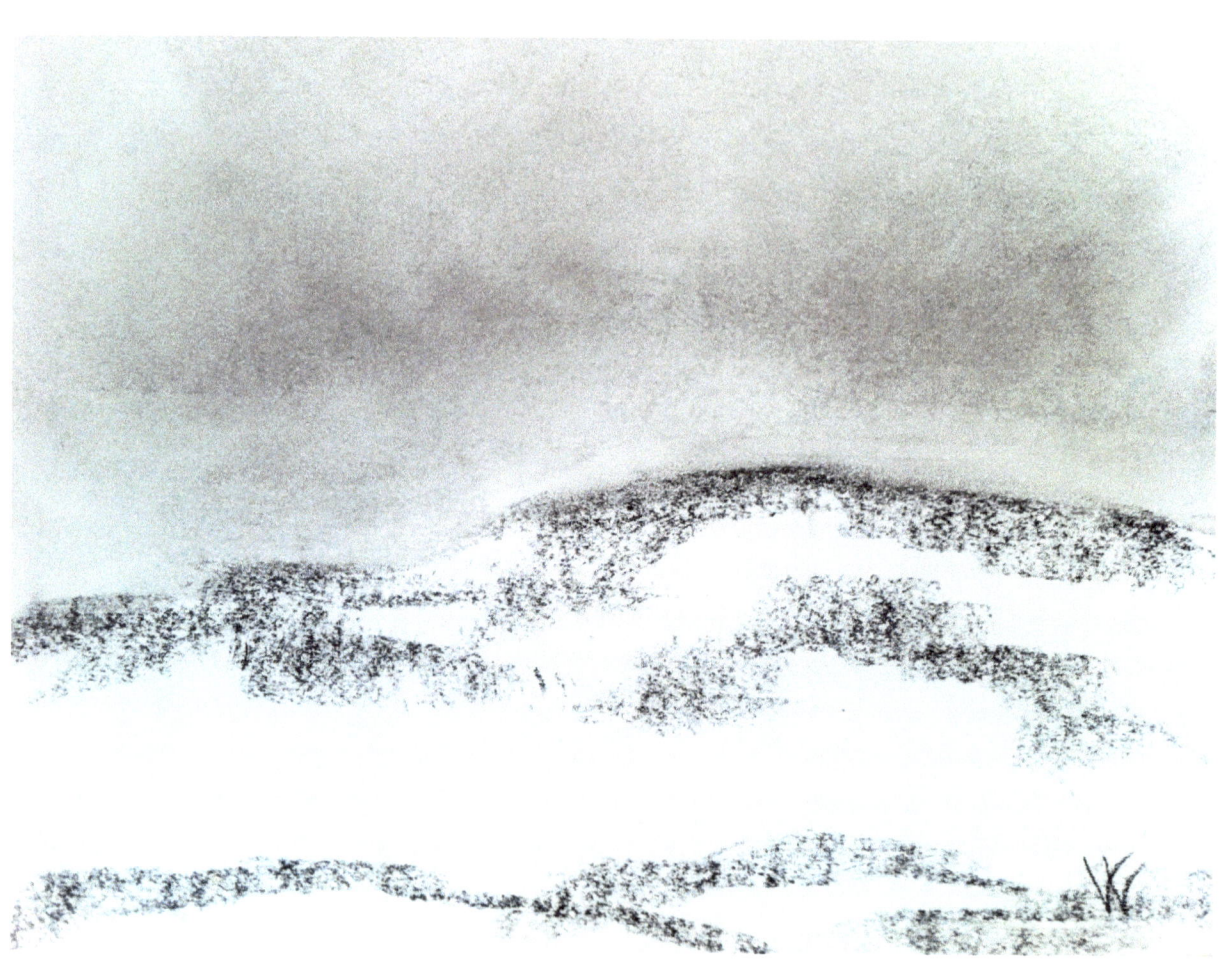

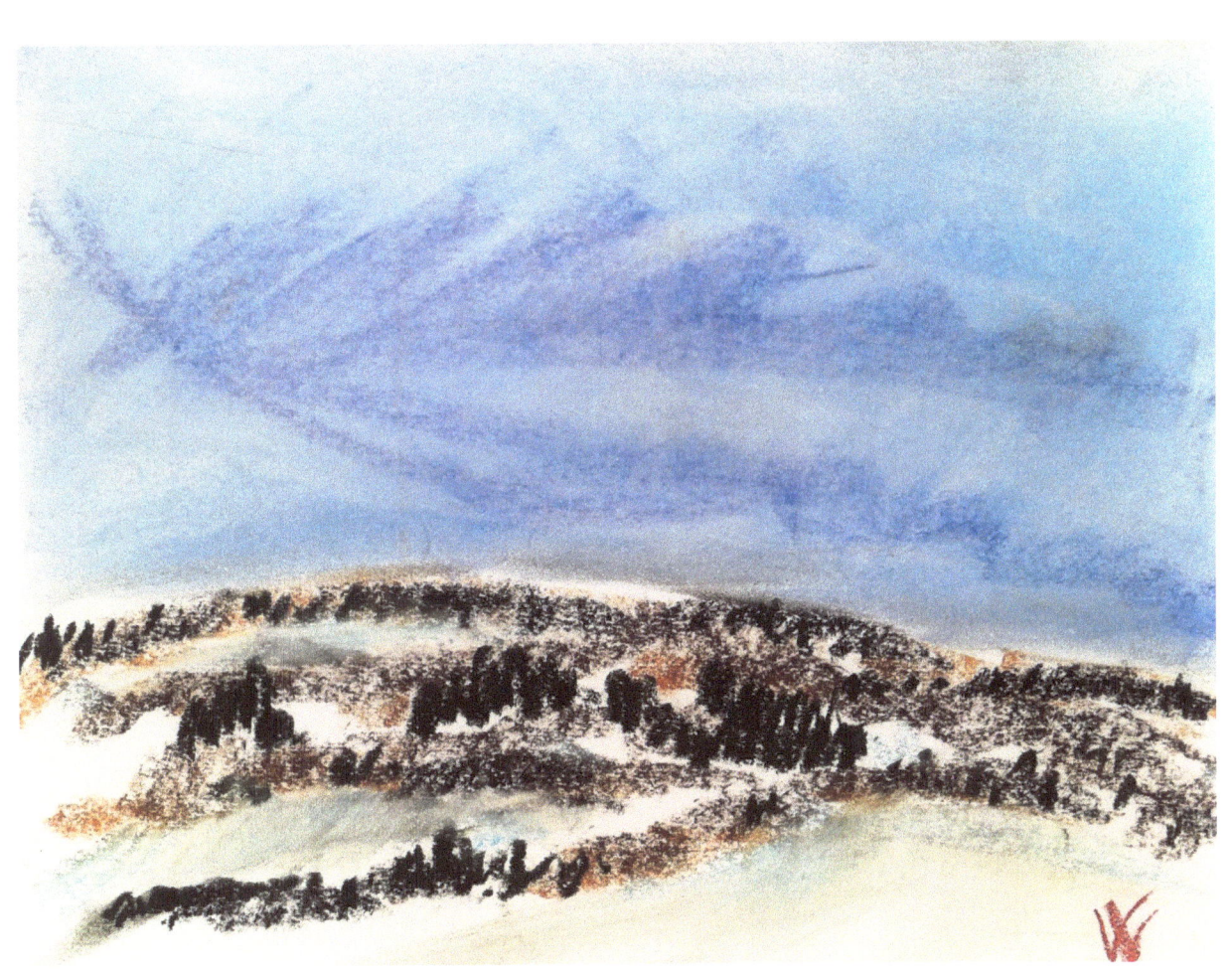

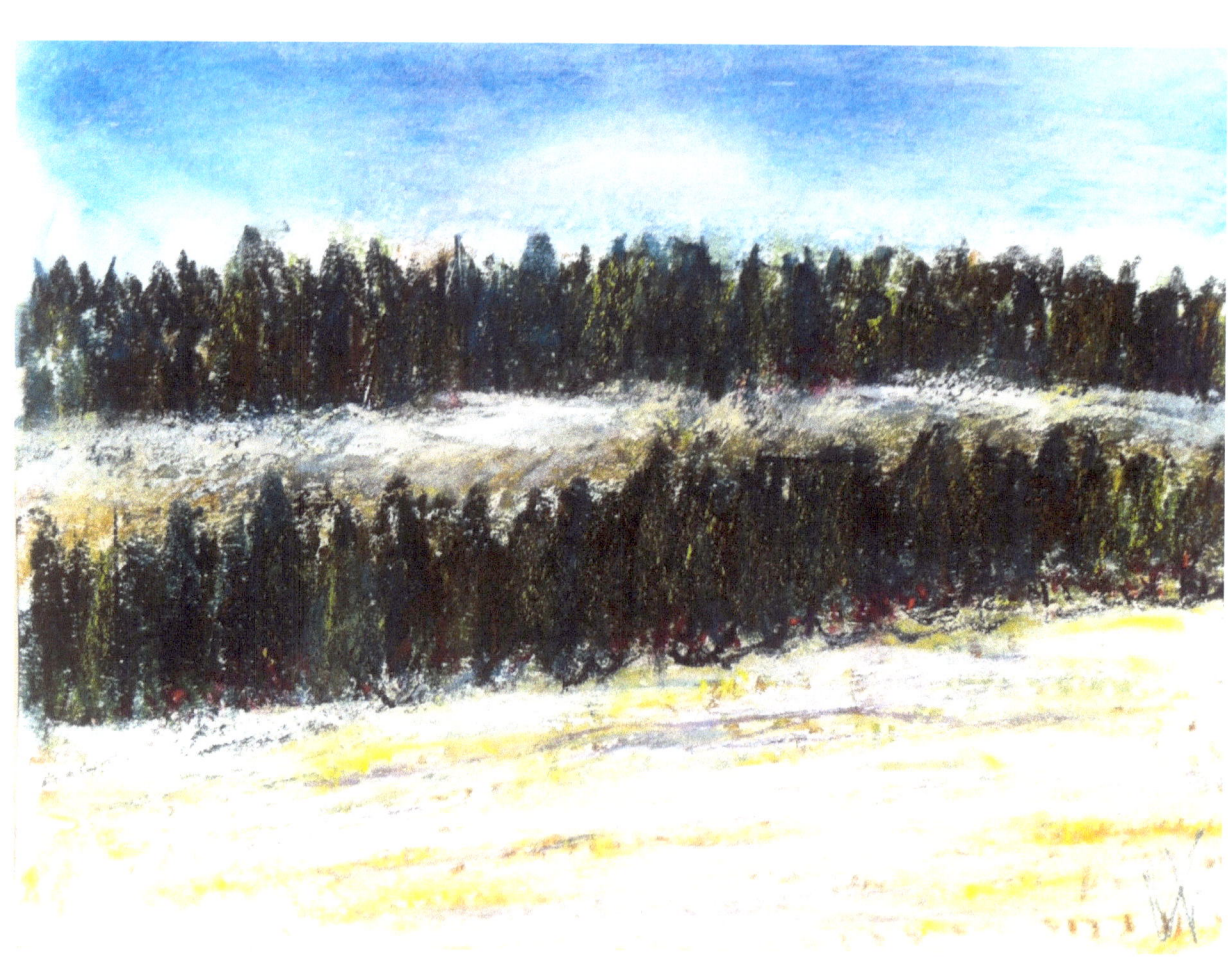

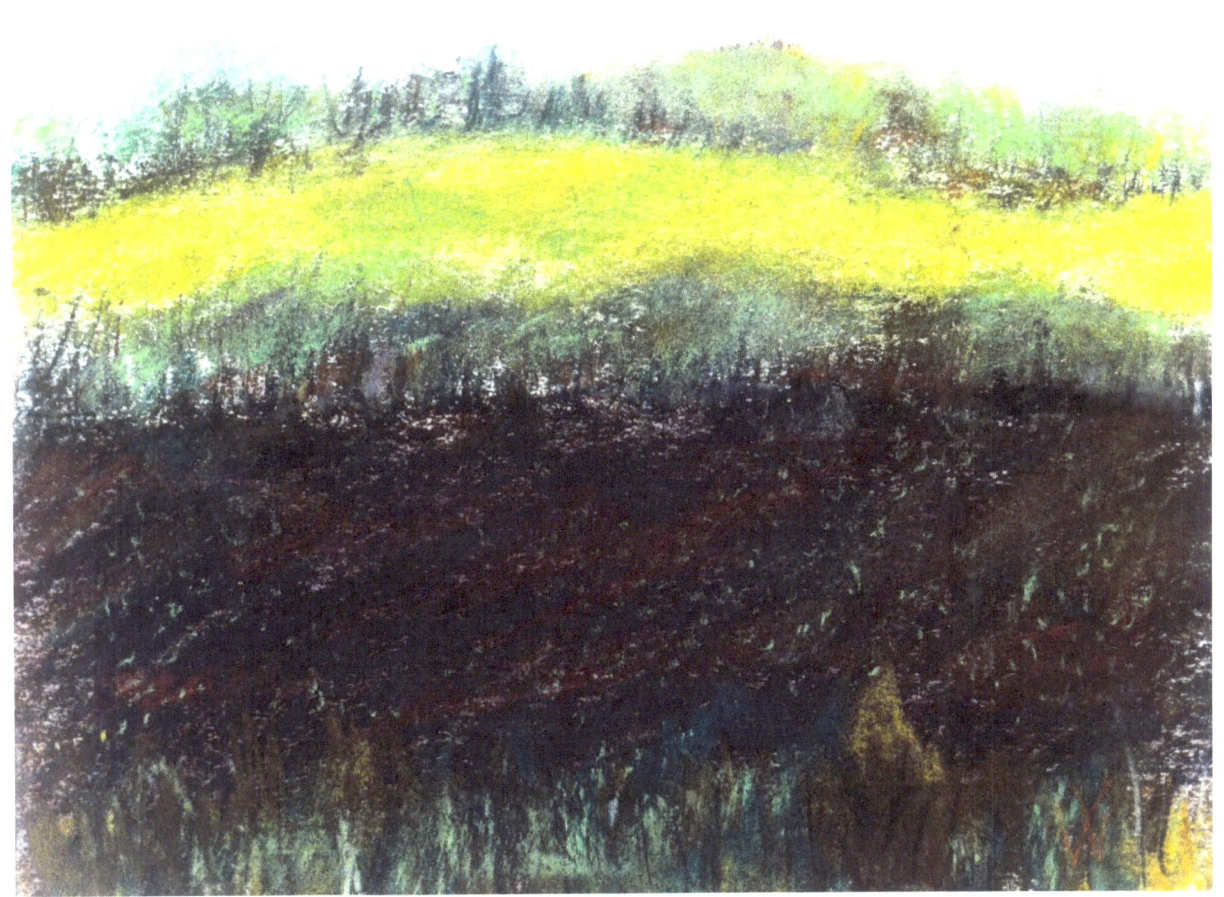

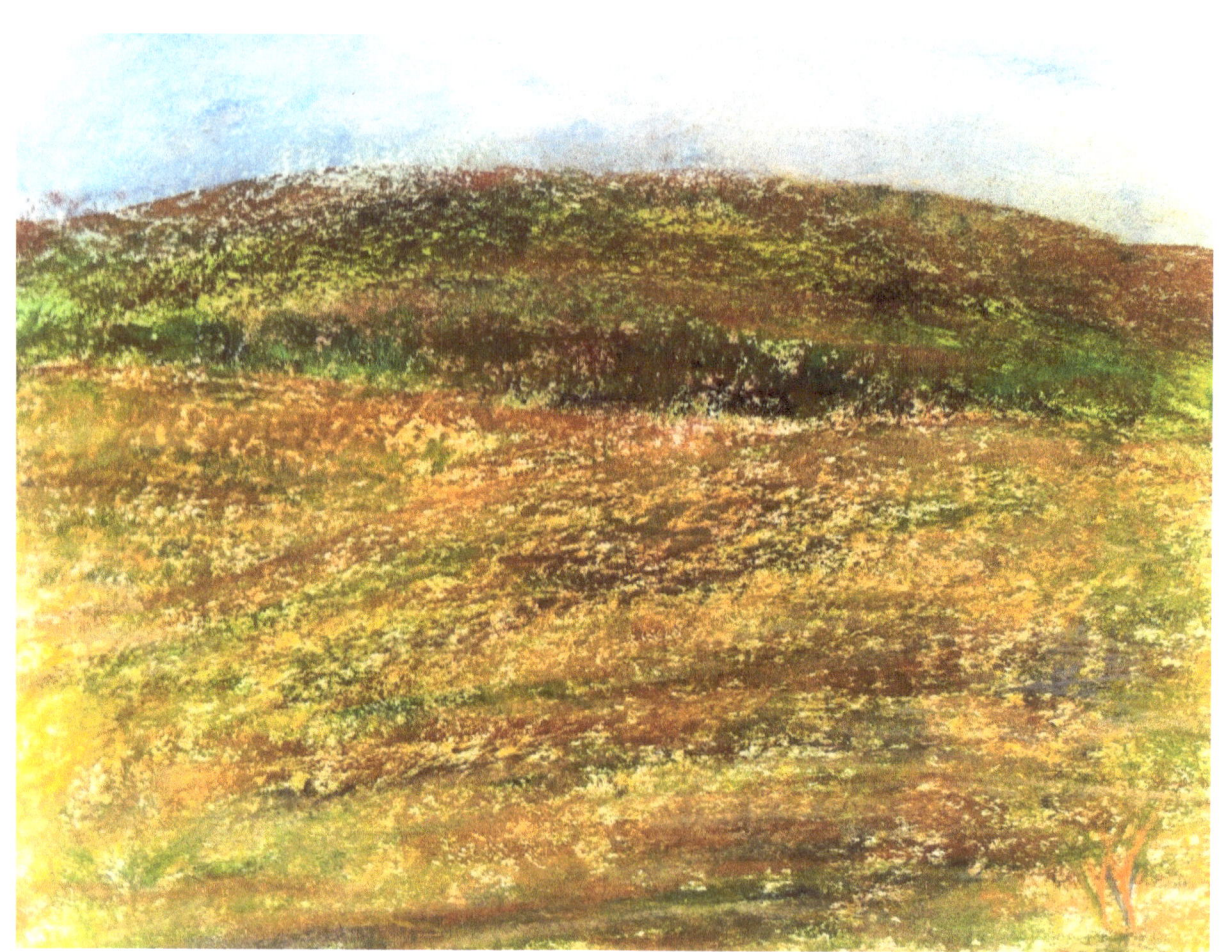

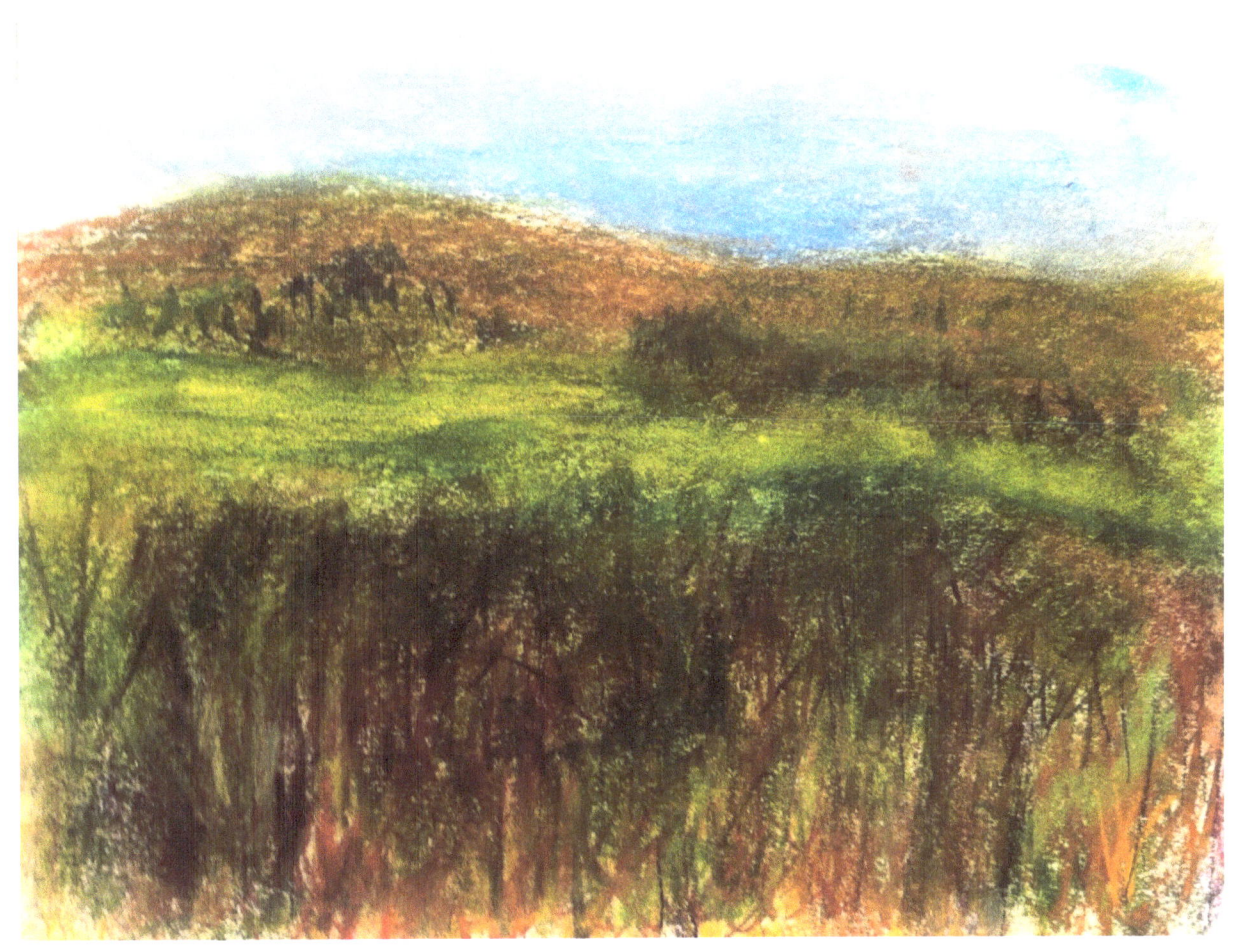

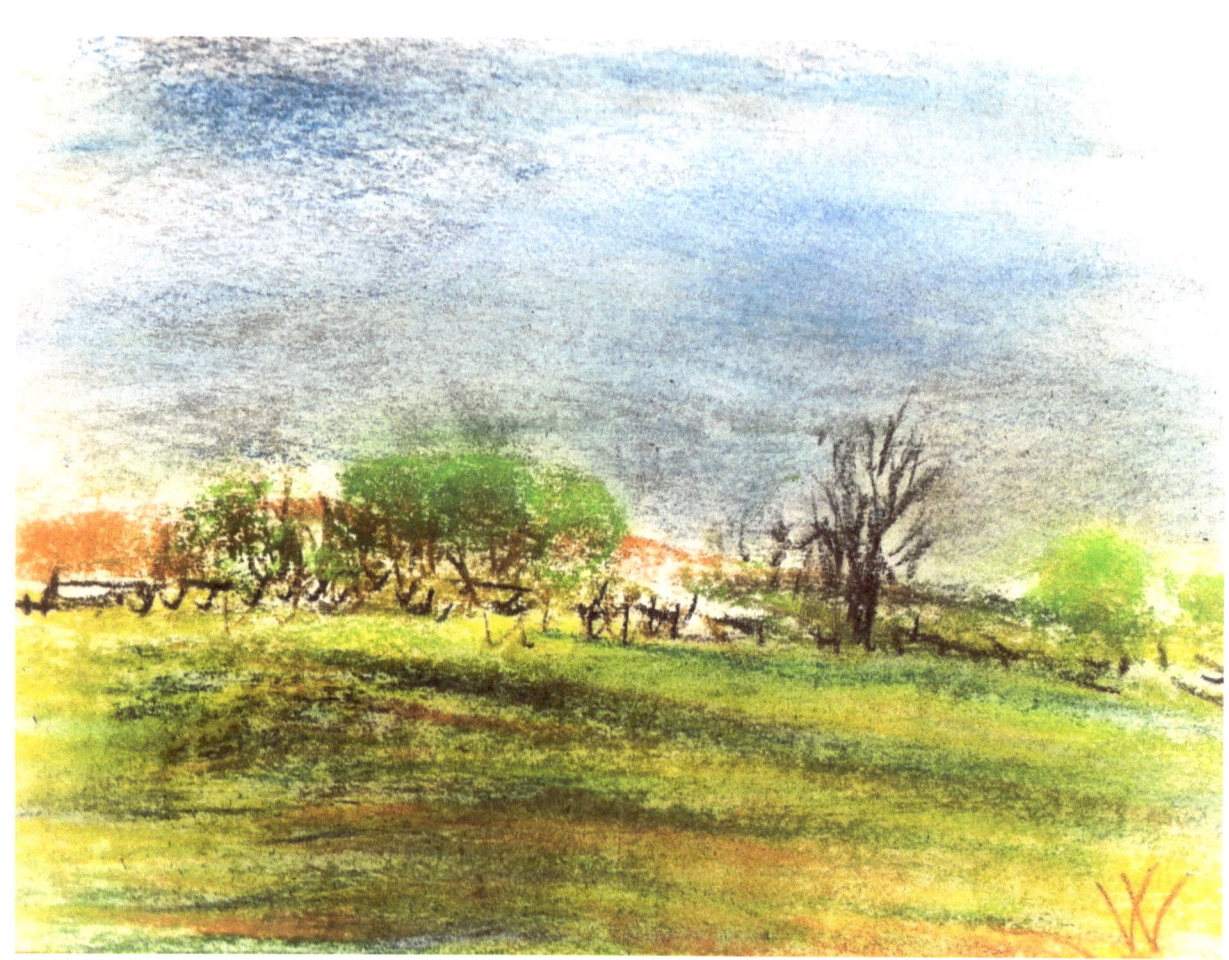

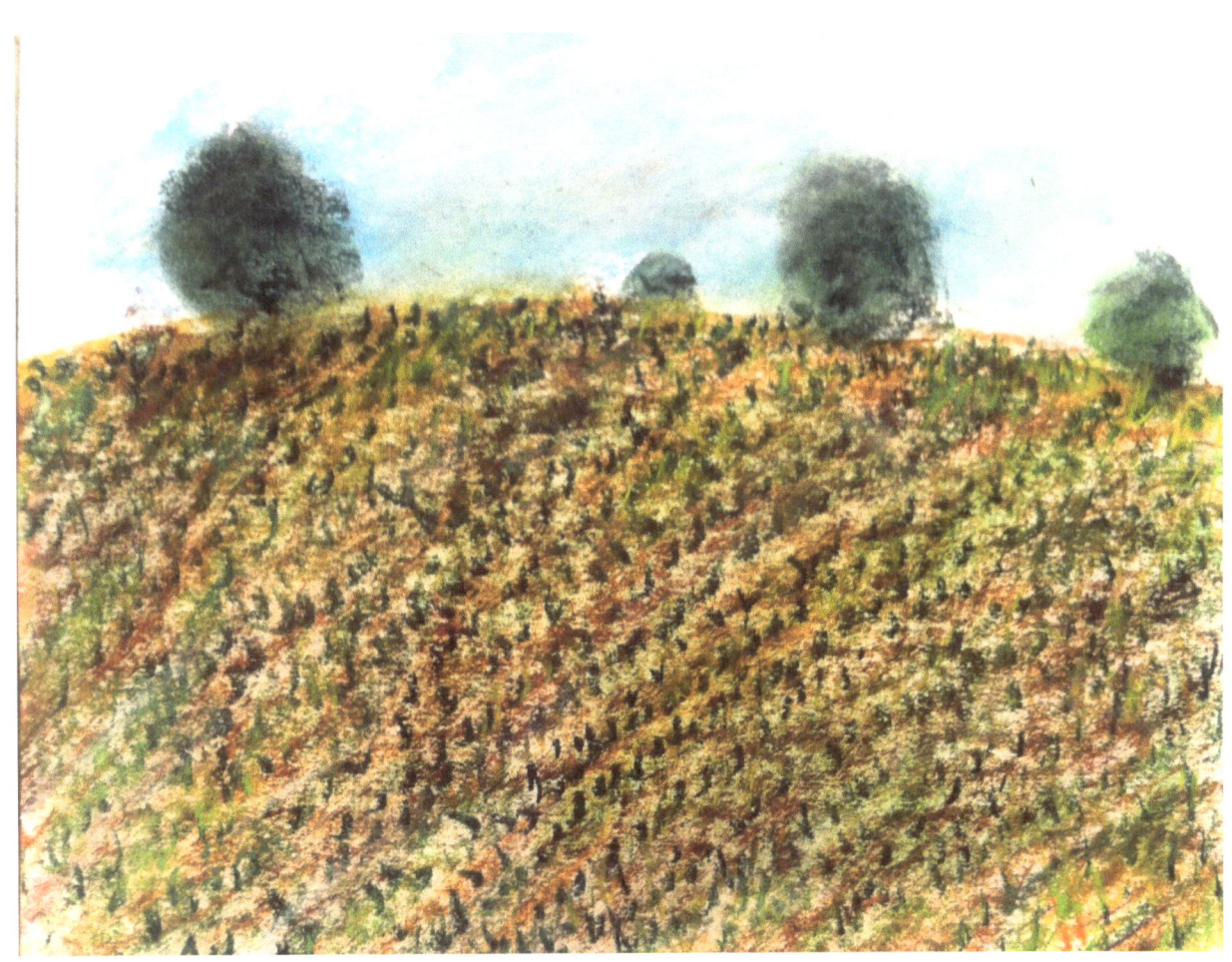

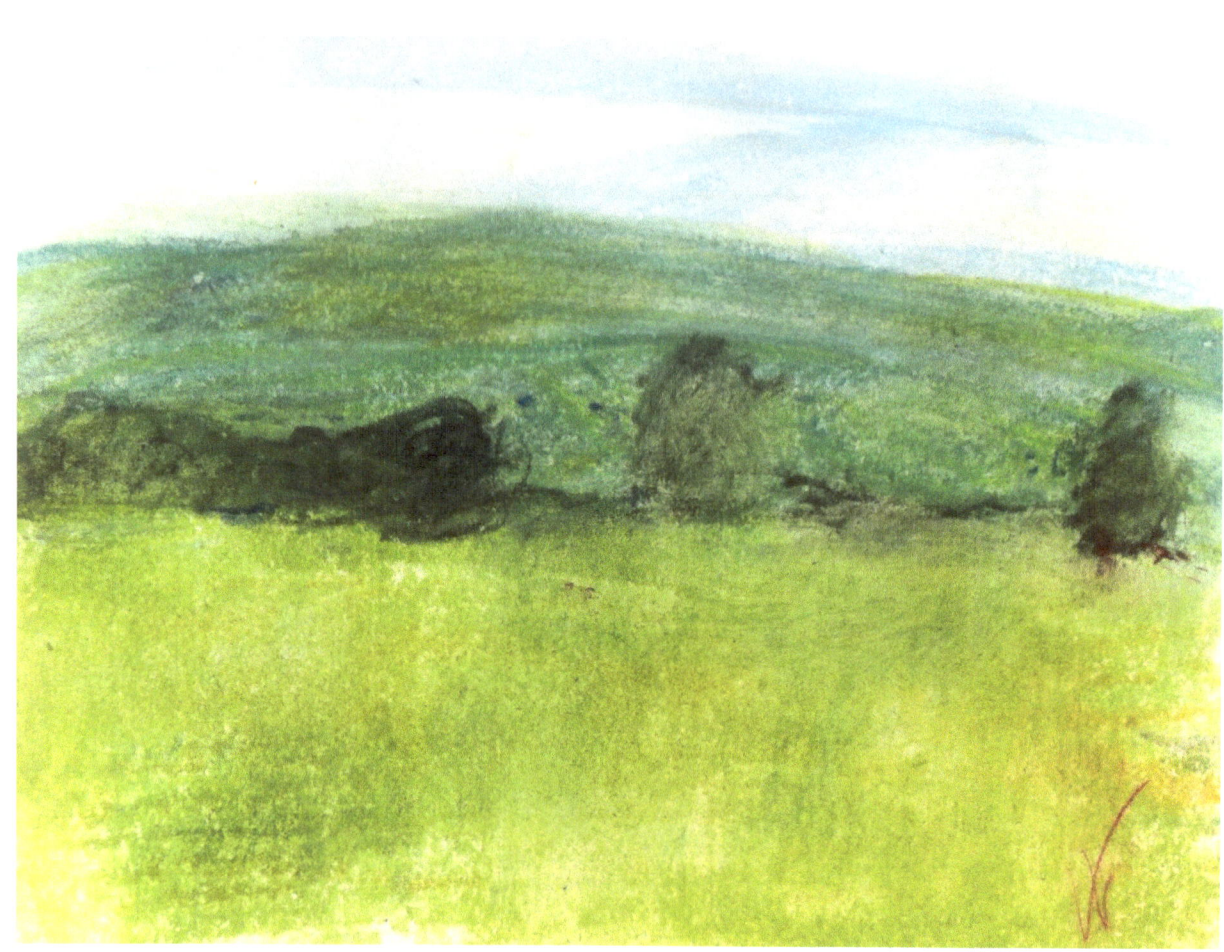

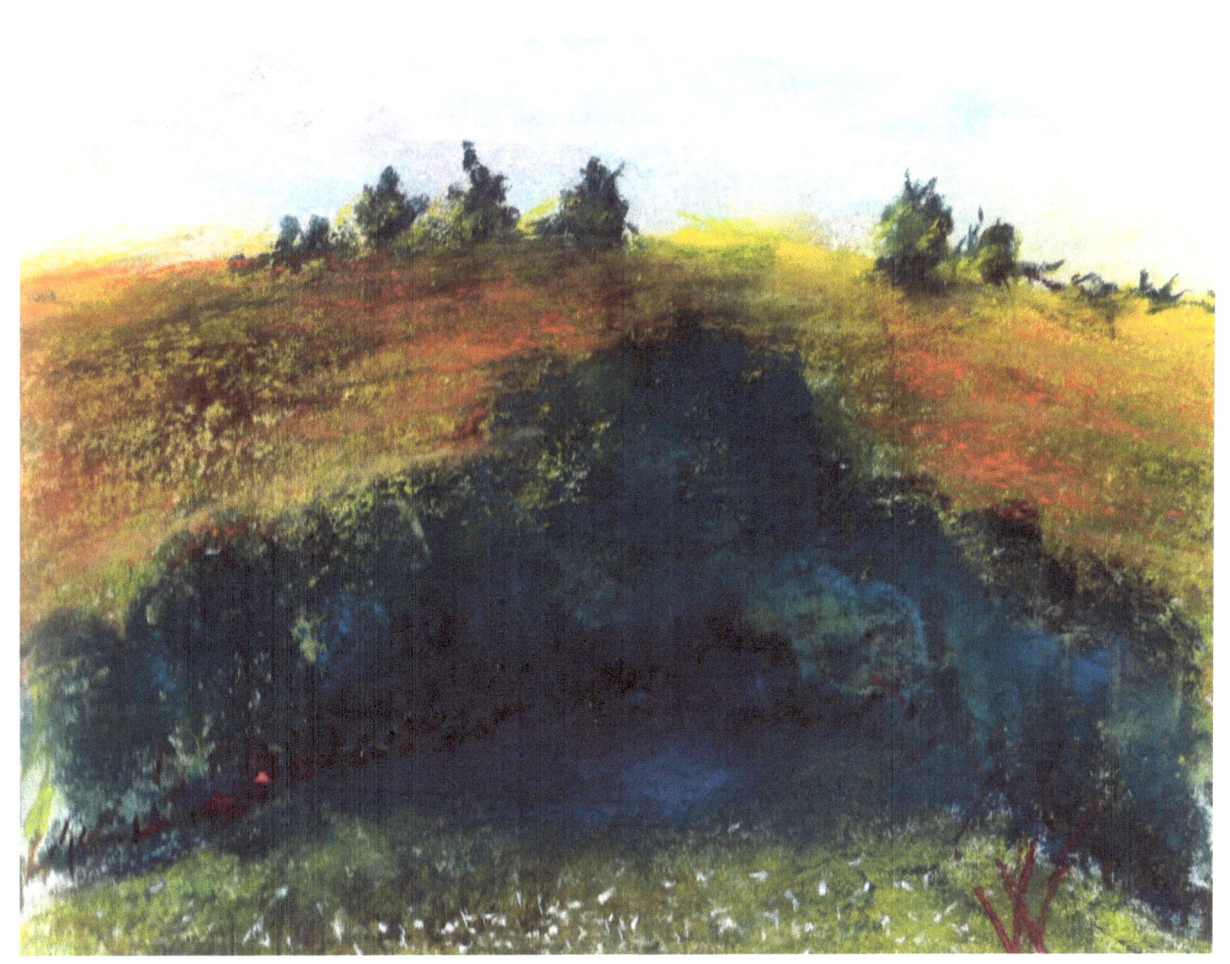

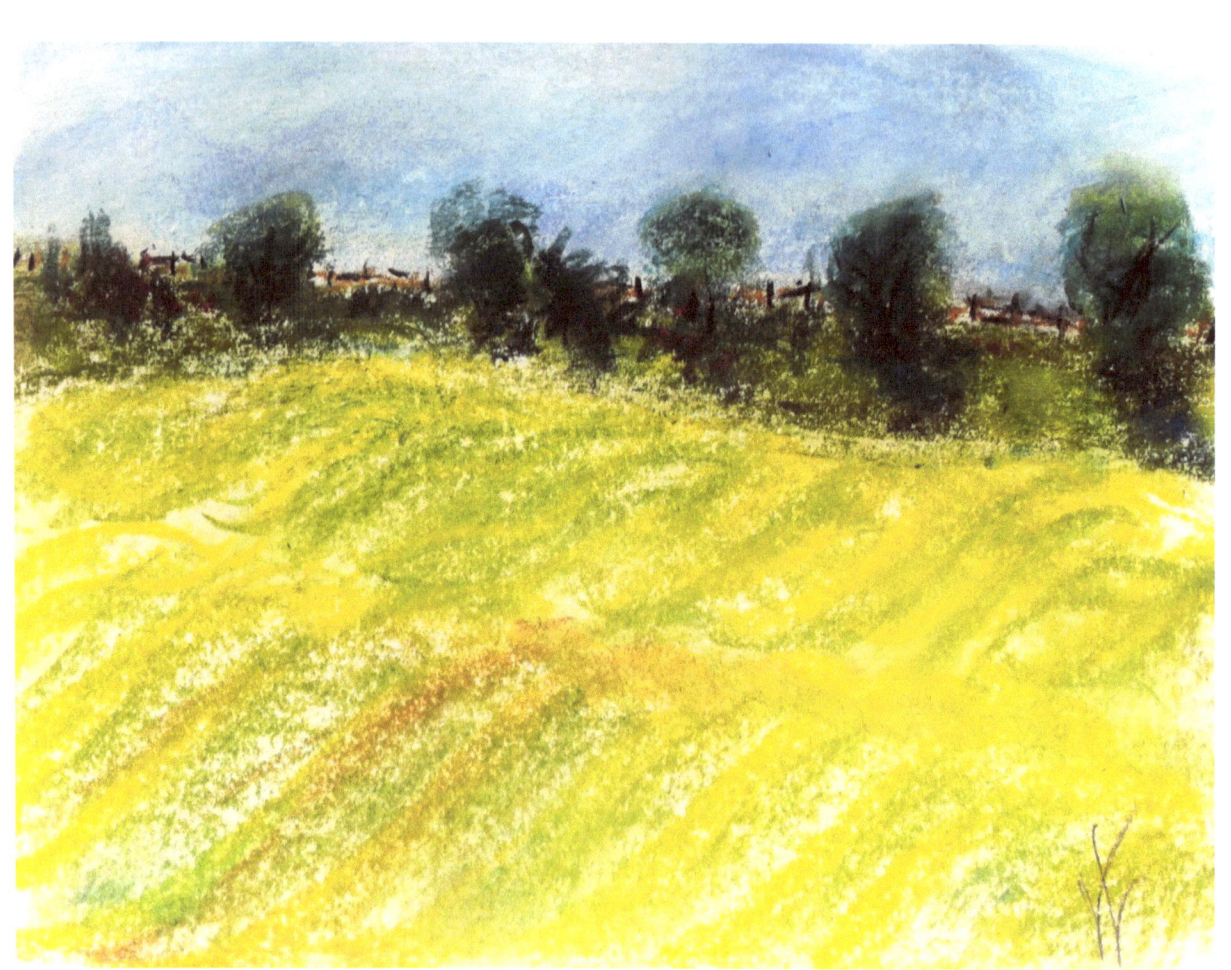

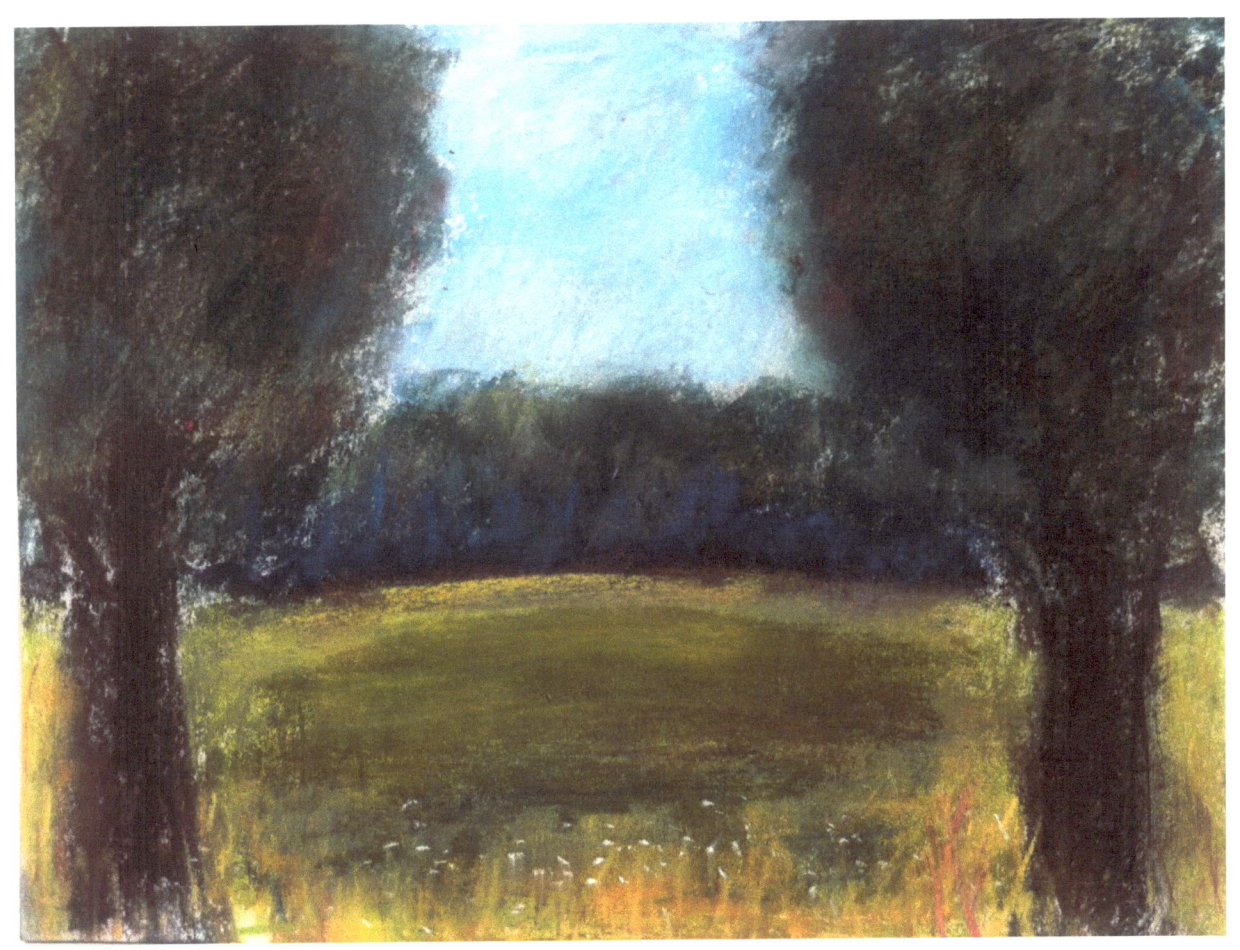

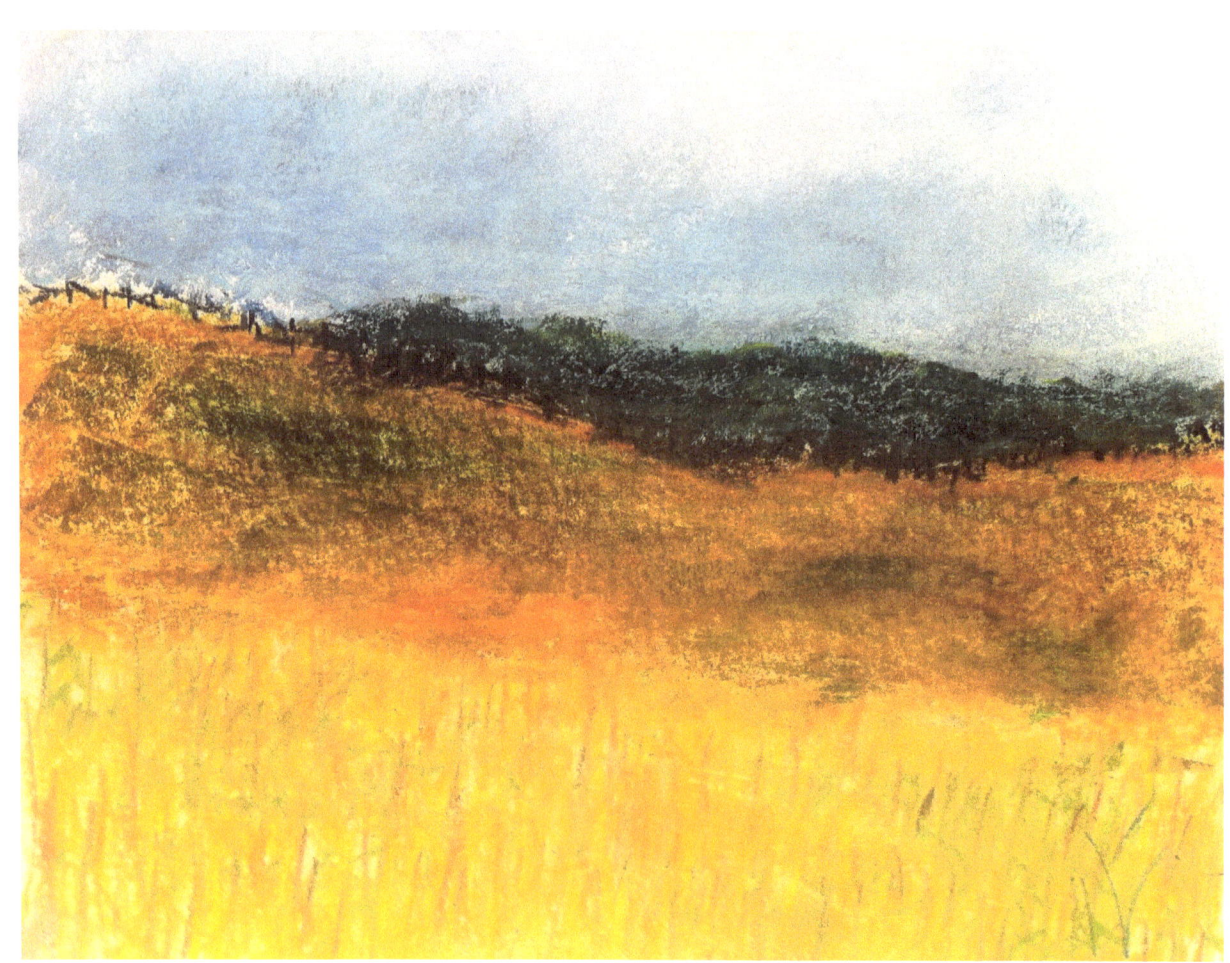

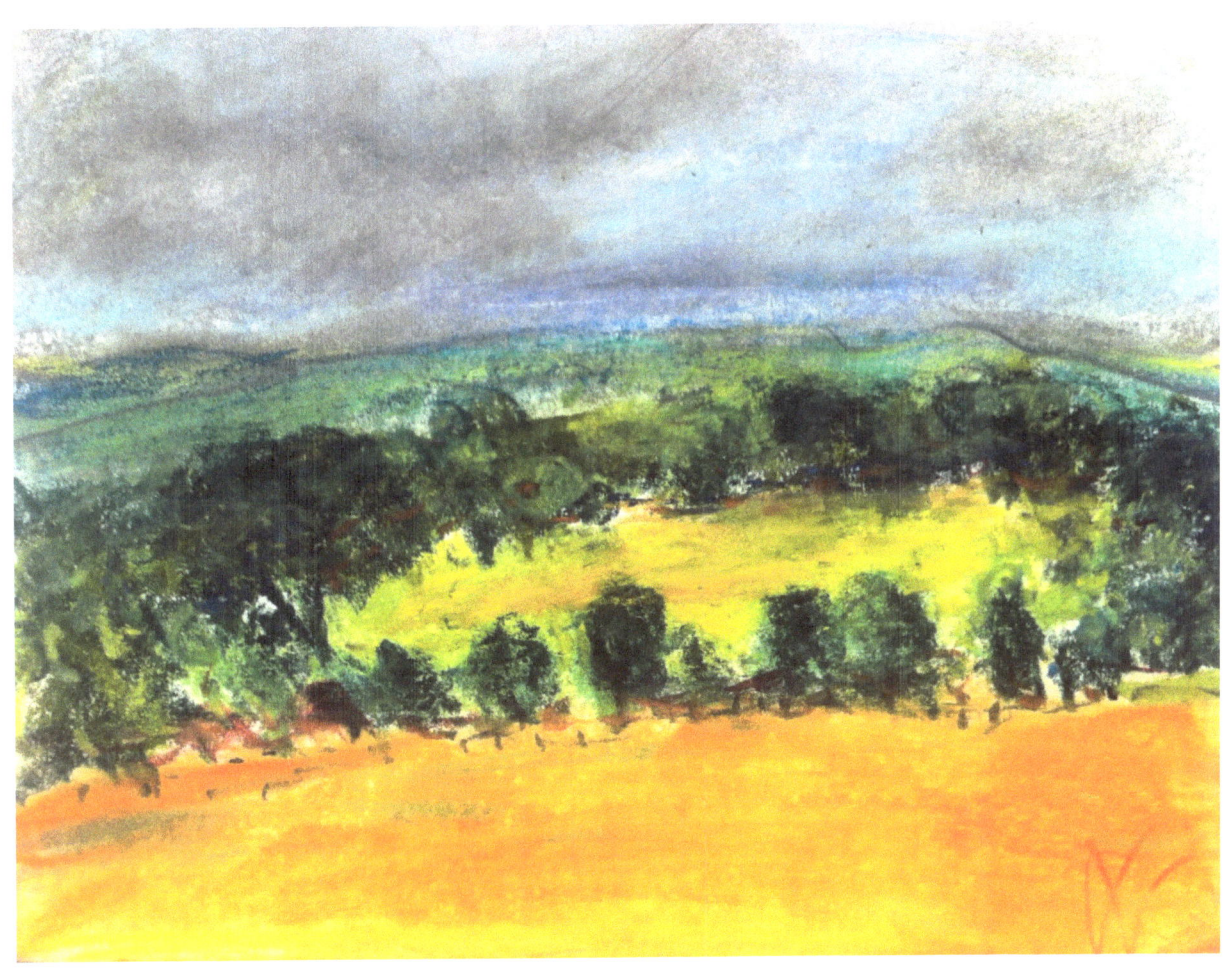

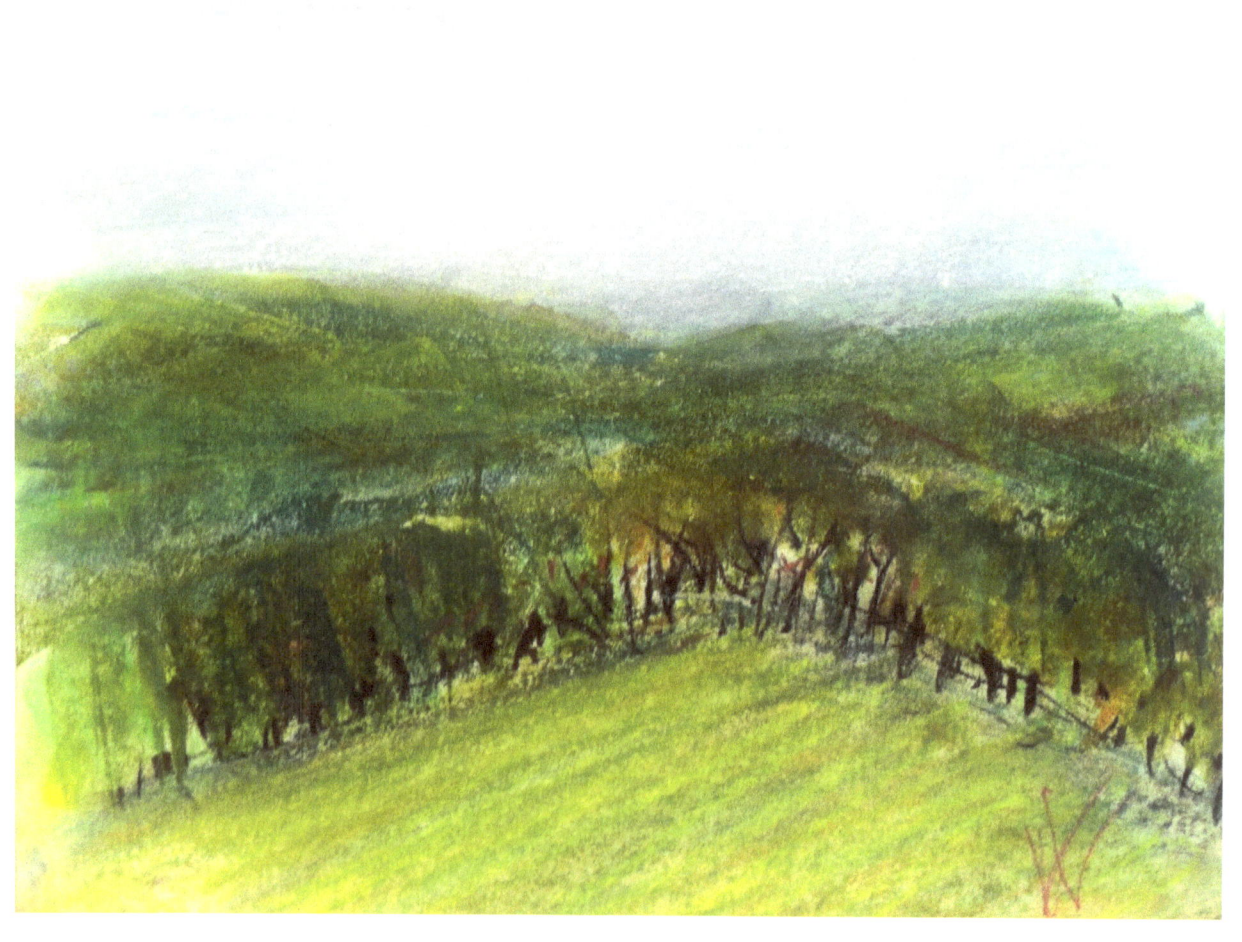

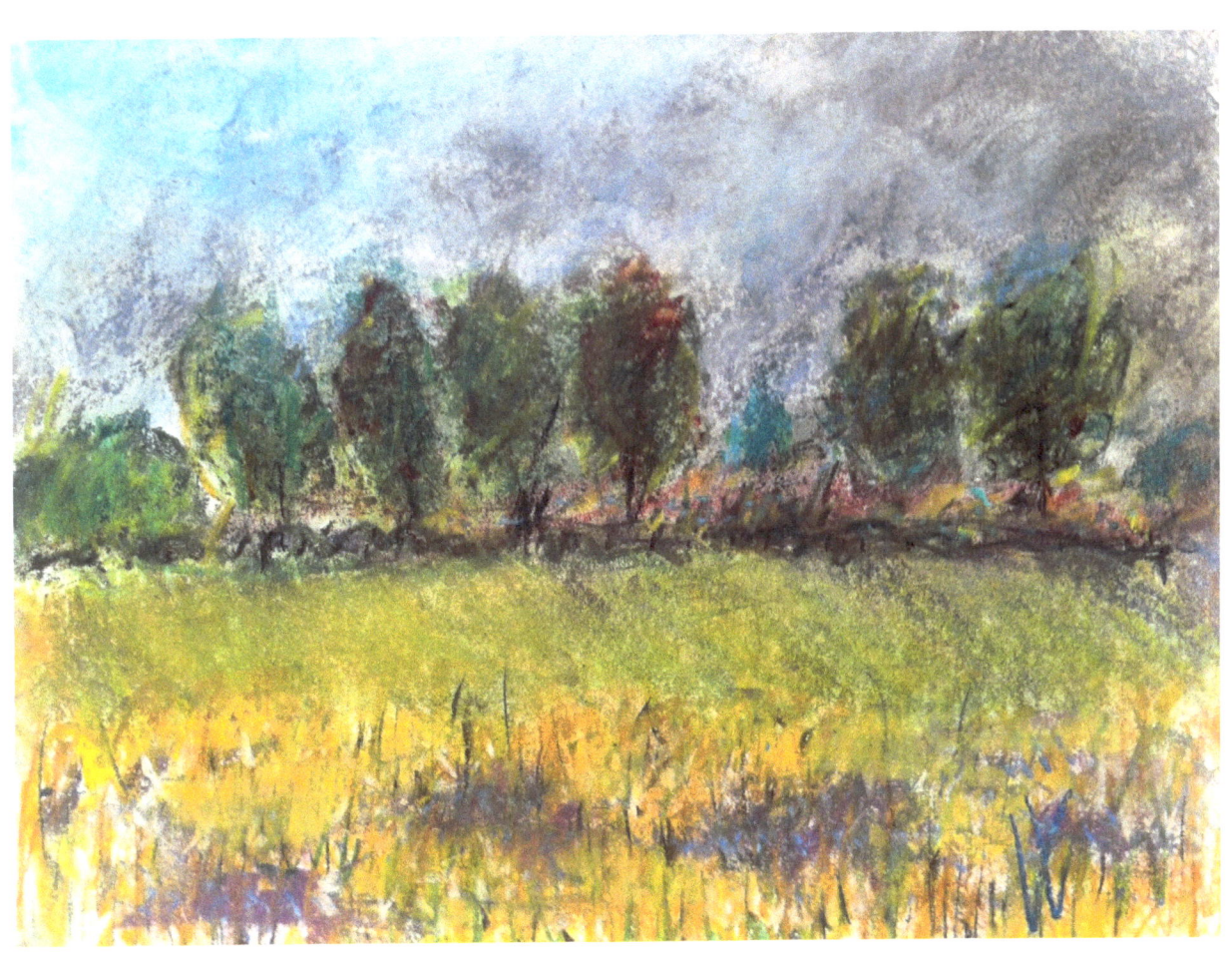

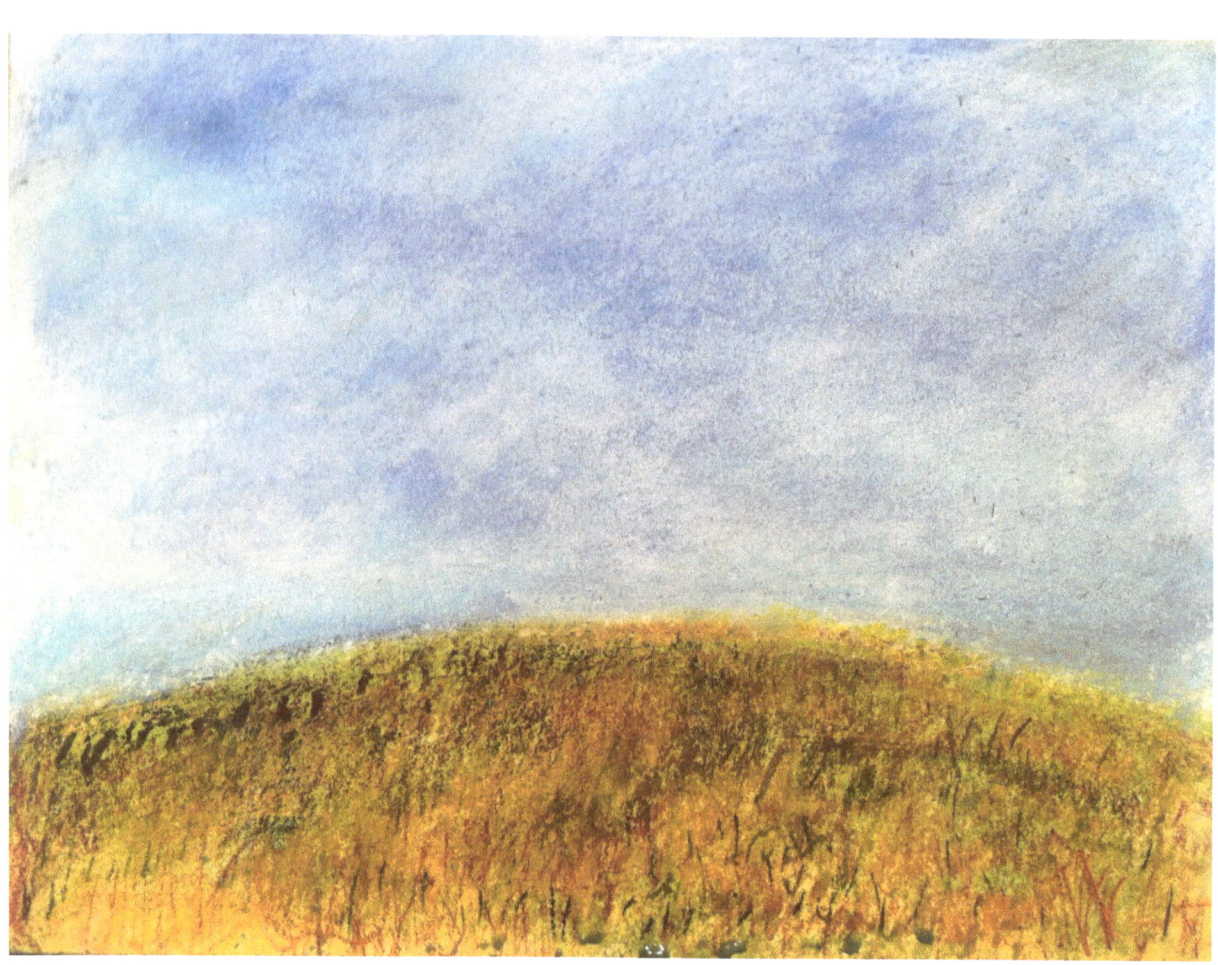

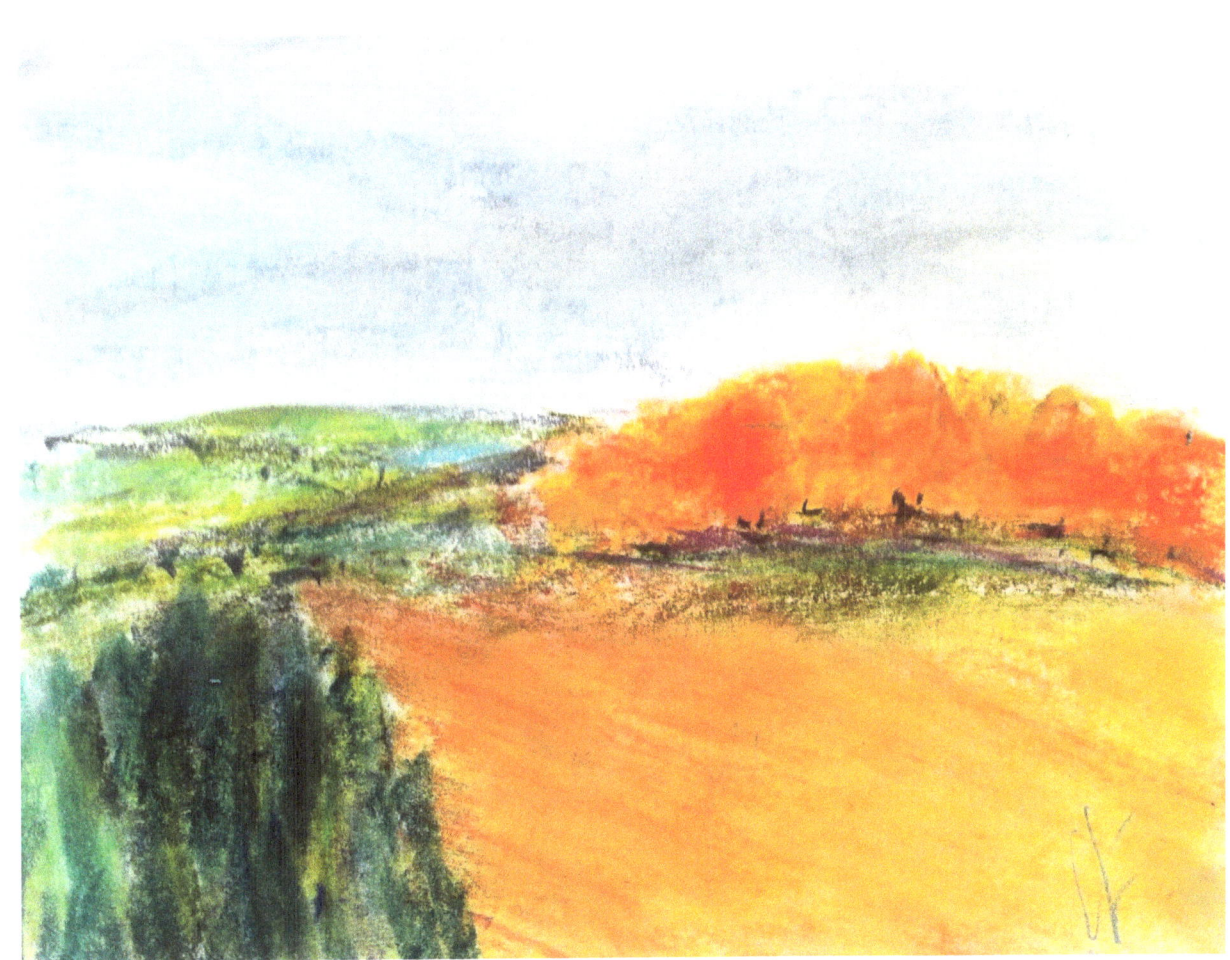

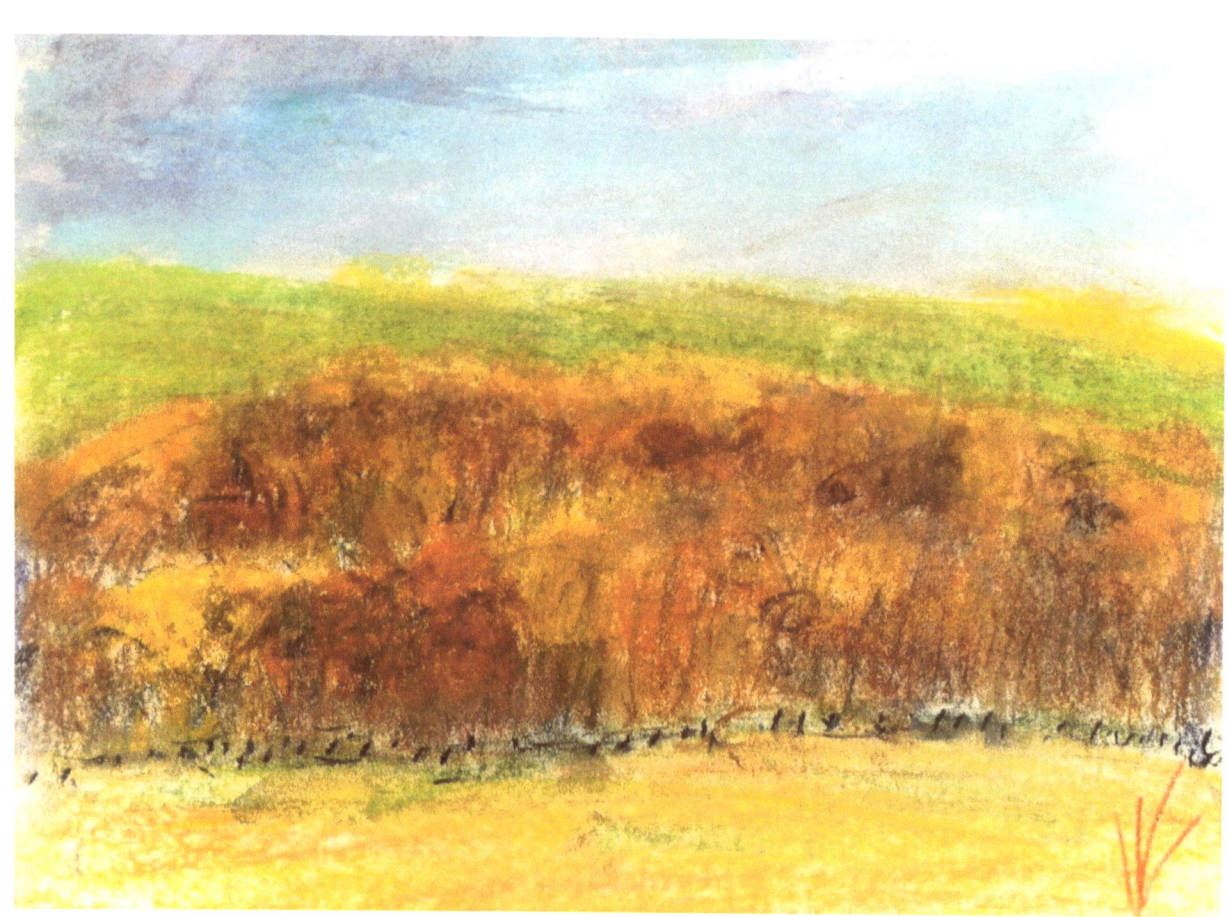

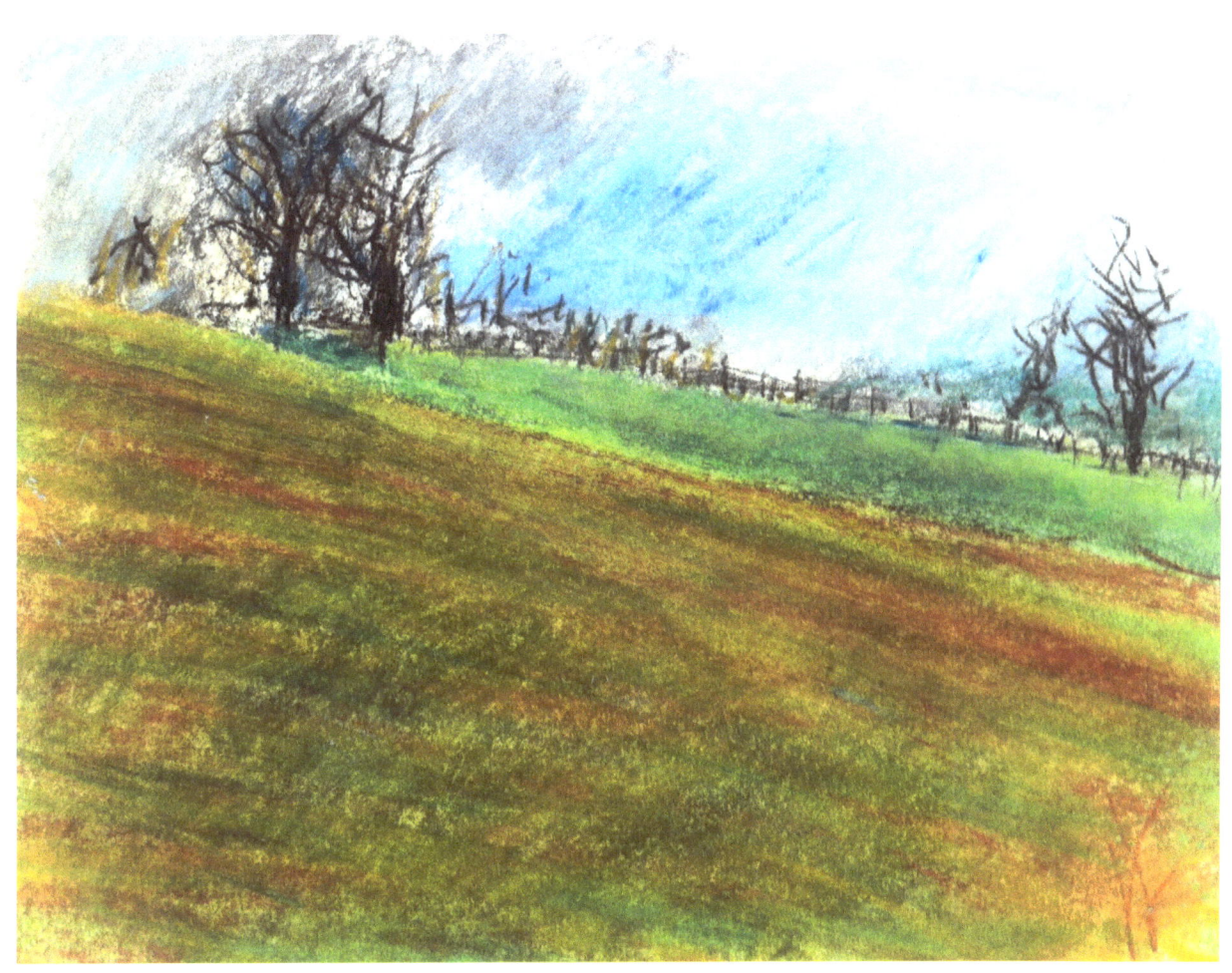

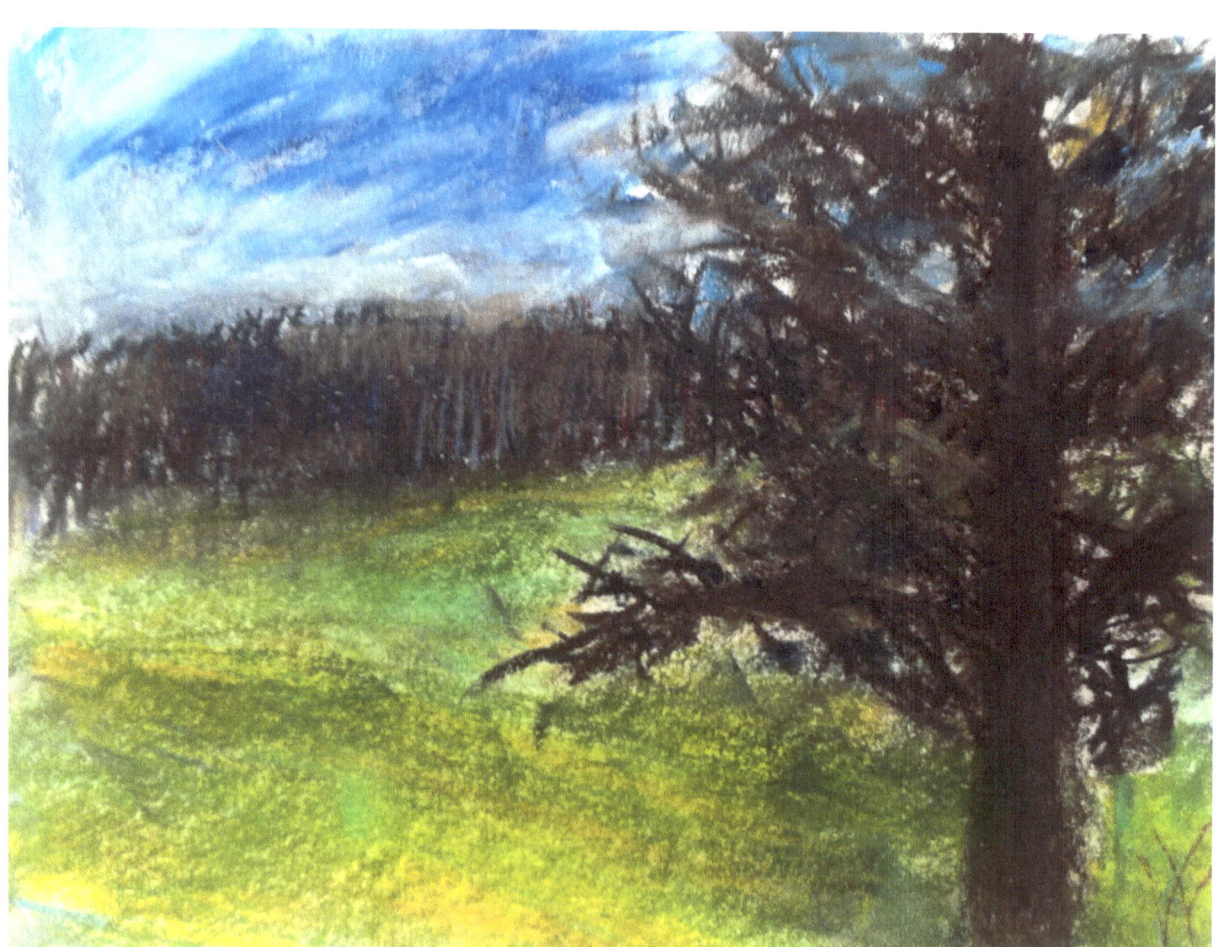

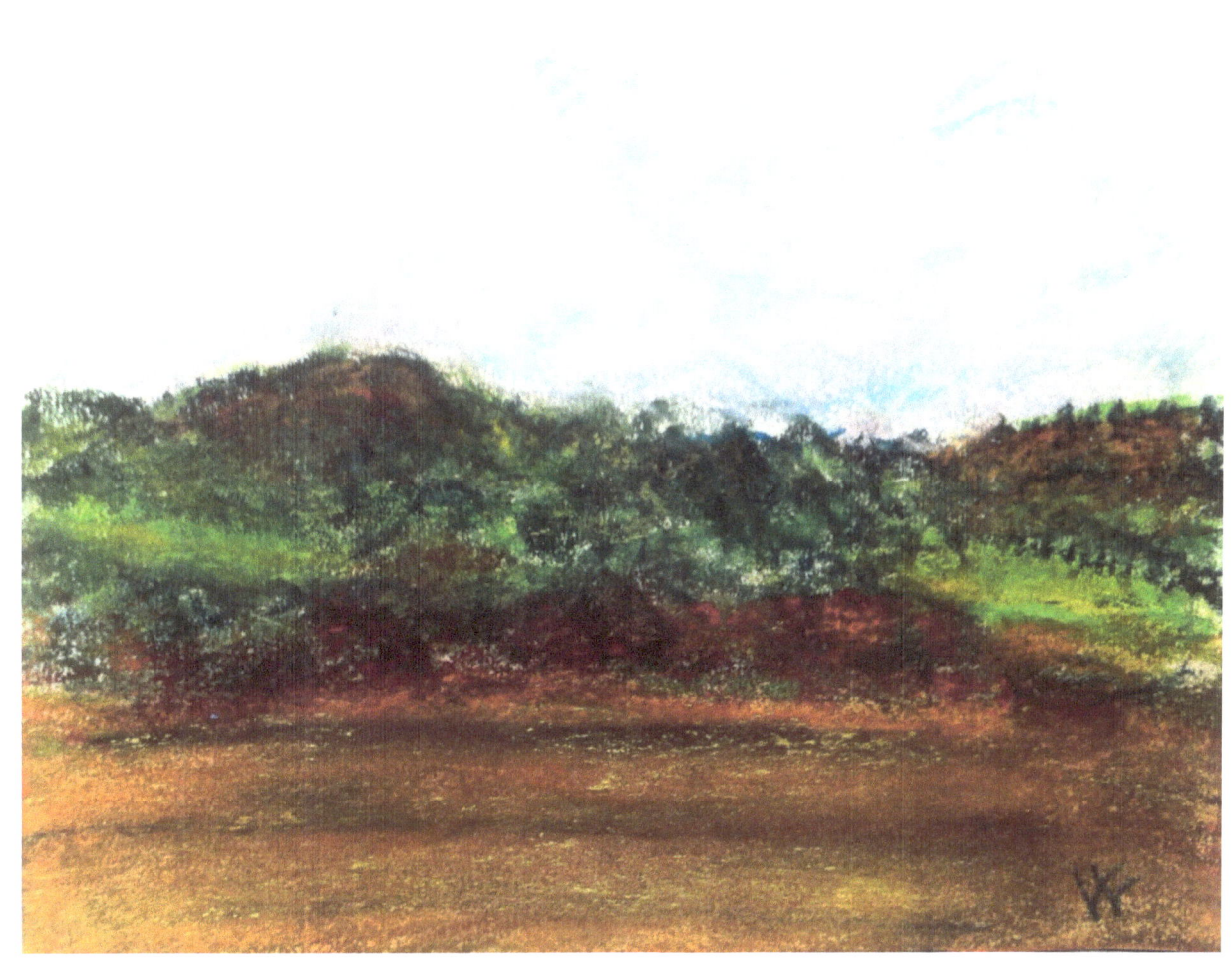

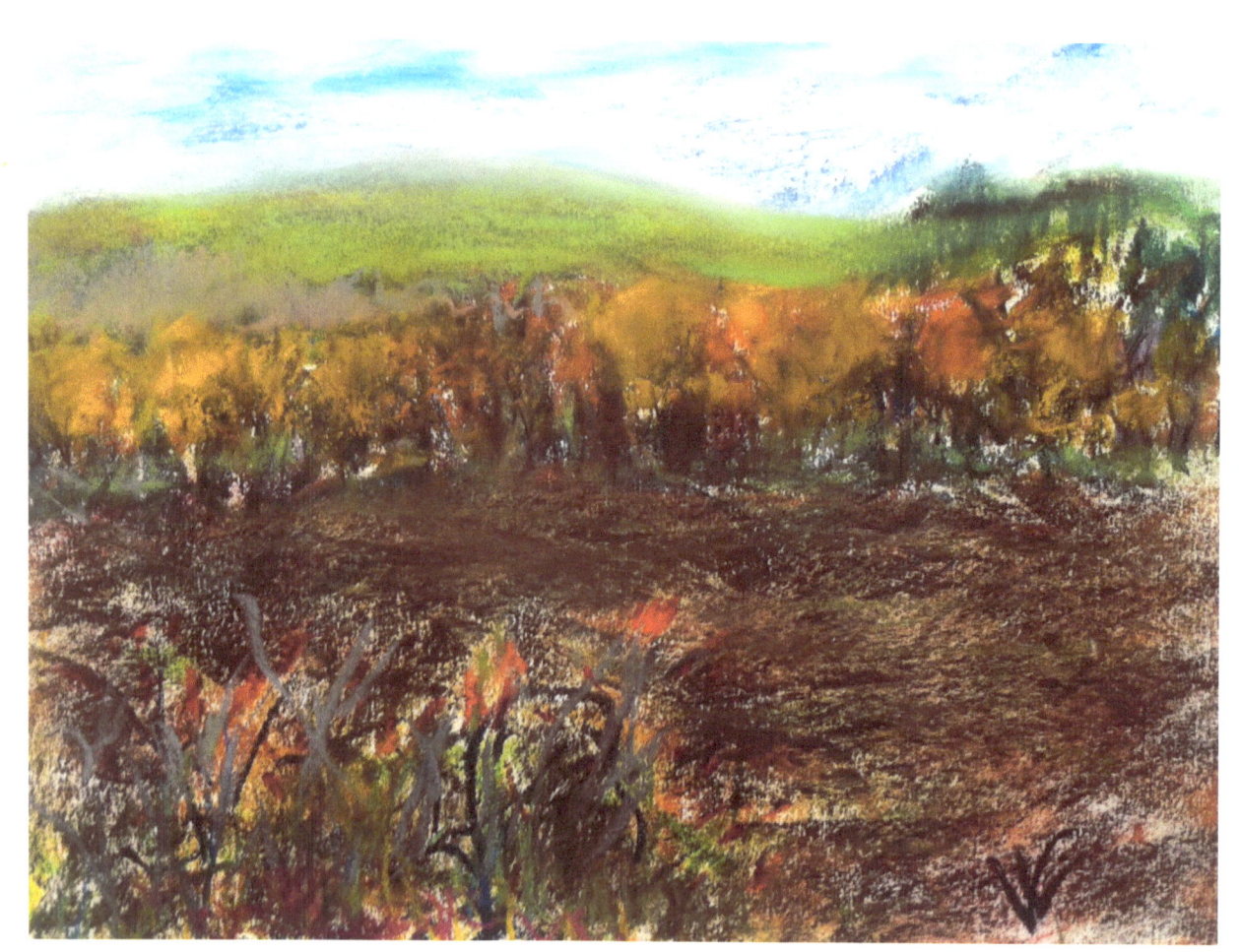

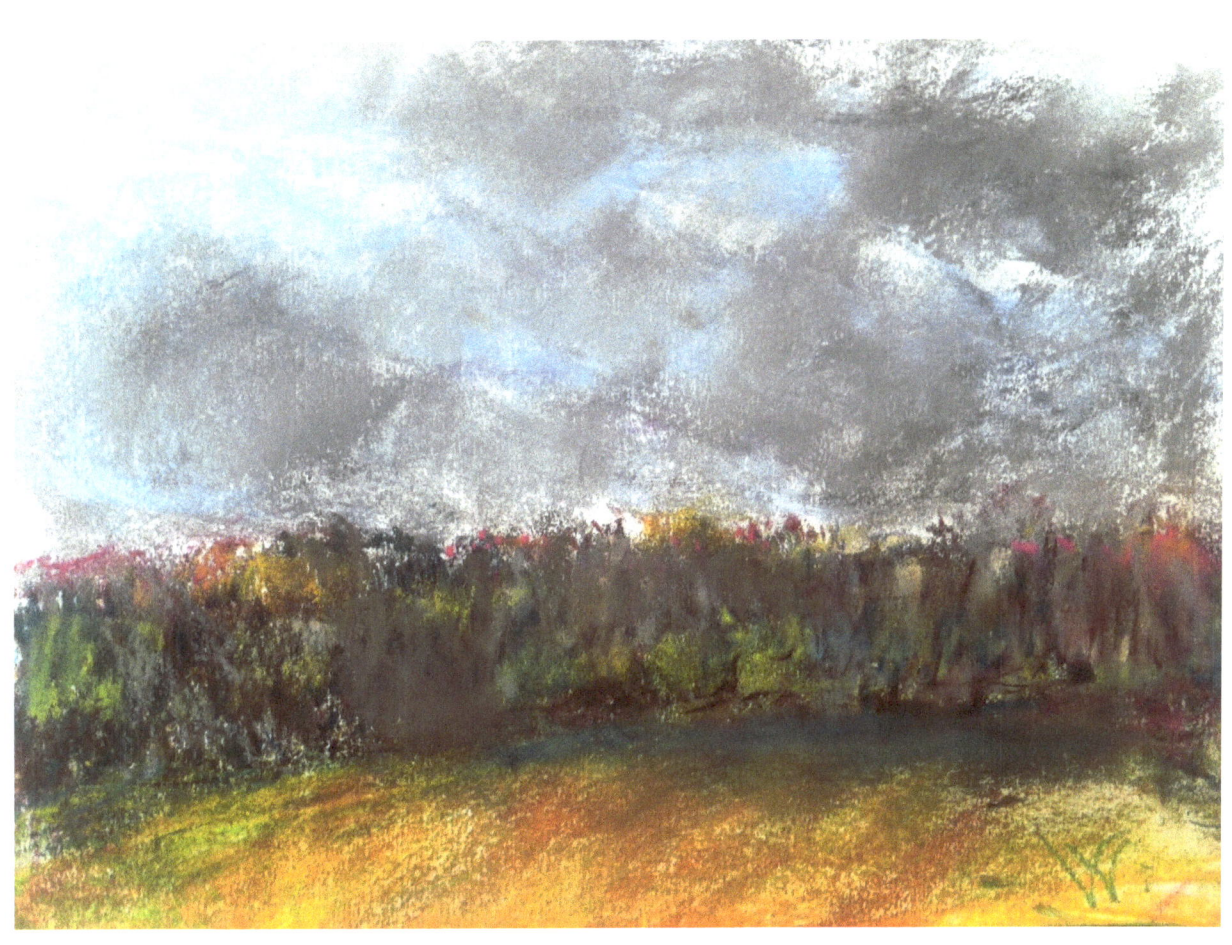

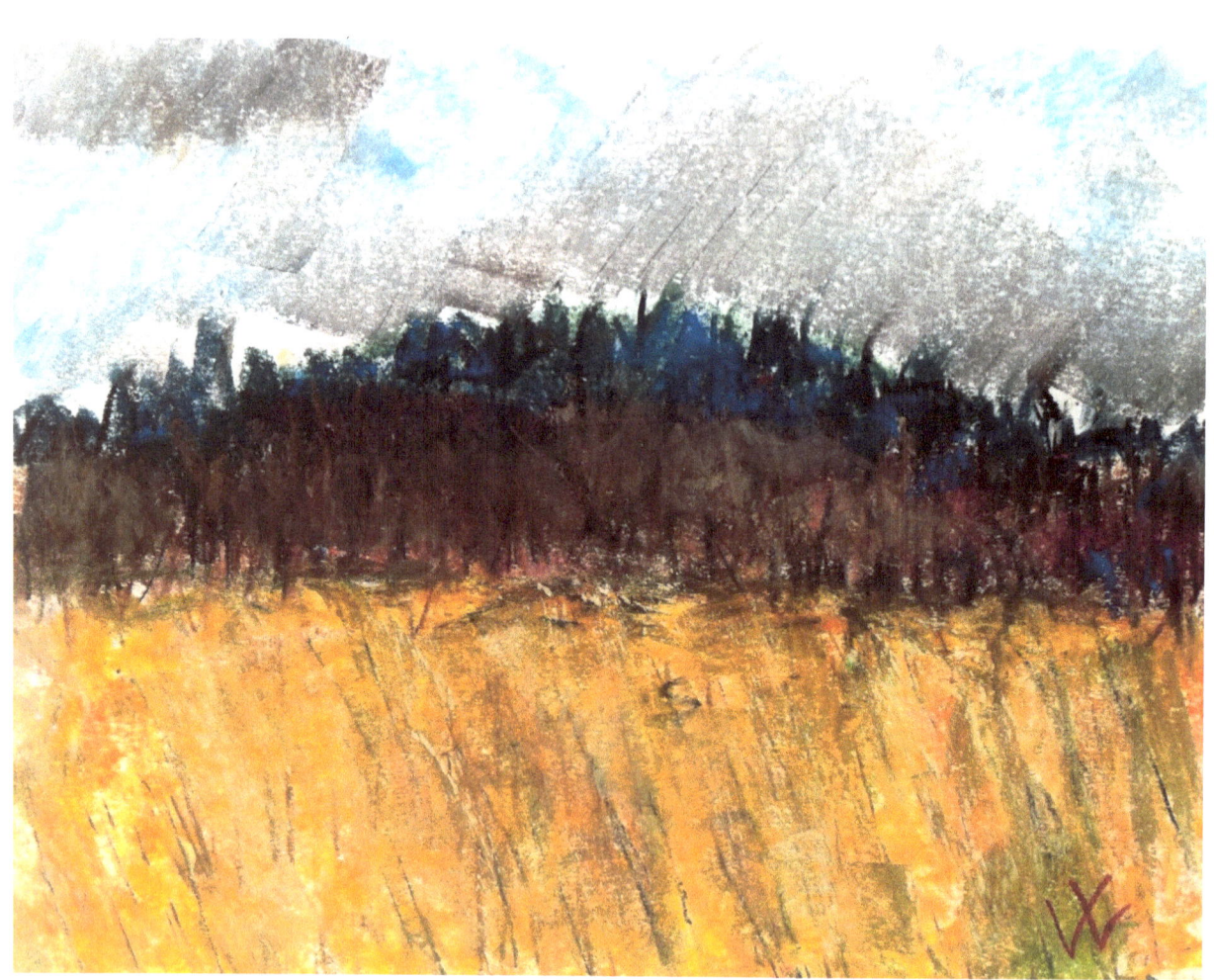

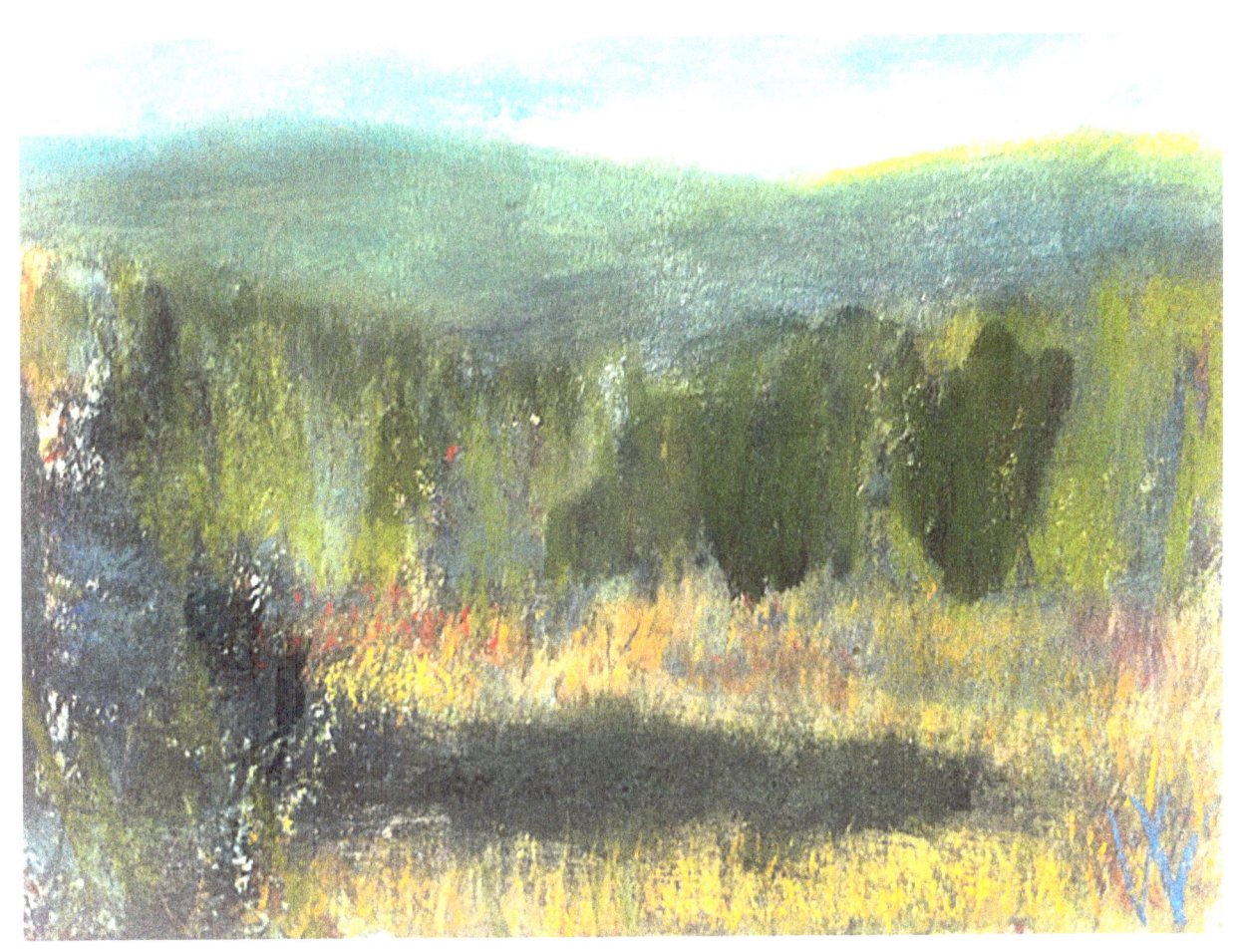

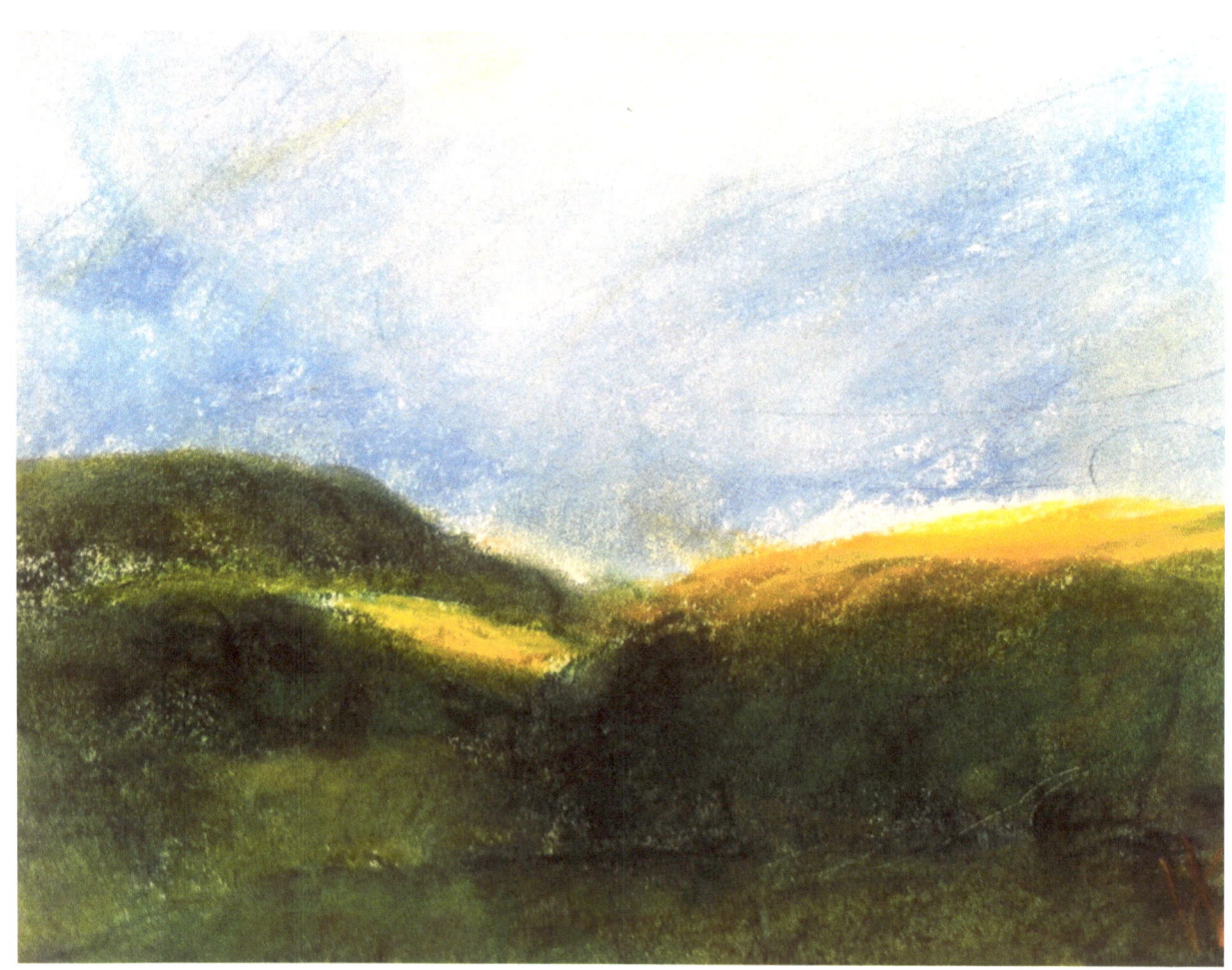

Afterword

Even a brief acquaintance with these hilly fields reminds us of the intense labor required to make and to till them or even to get to them. The crops were and remain pasture and hay, grains, corn, and more recently soy which turns a ruddy orange when ripe. There were many apple orchards and part of our place was one such orchard slowly emerging from the overgrowth of many years. Thanks then to our forbears and to the native peoples who showed them the way.